P9-DFJ-038

To Pat, a queen of Greenville,
Love you.

Gannion Keisher
6/29/02

Stockbridge Massachusetts
June 29, 2002 After Tanglewood
PHC (@ The Red Lion Courtyard)

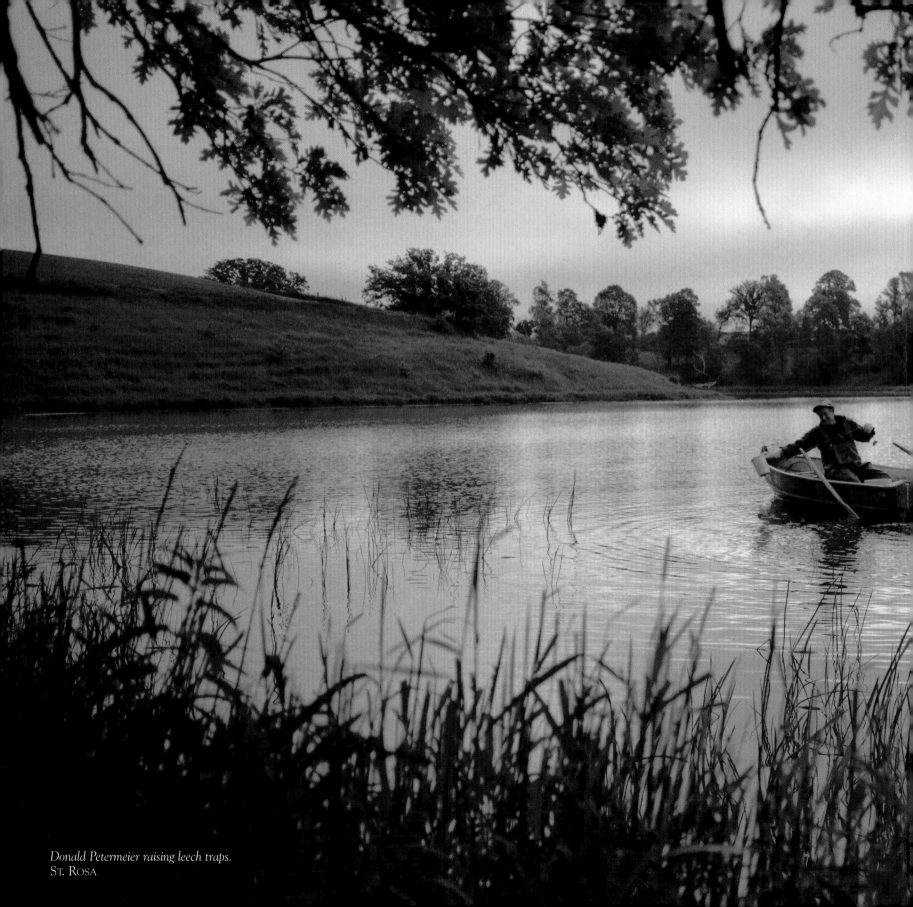

Donald Petermeier raising leech traps.
ST. ROSA

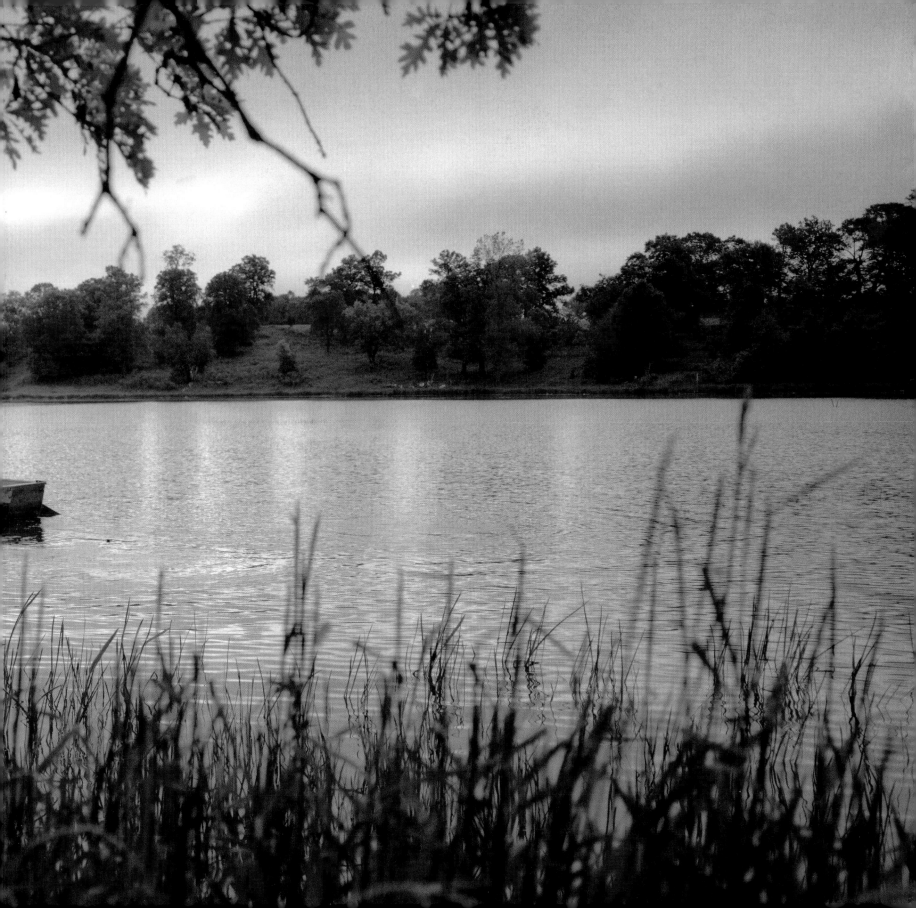

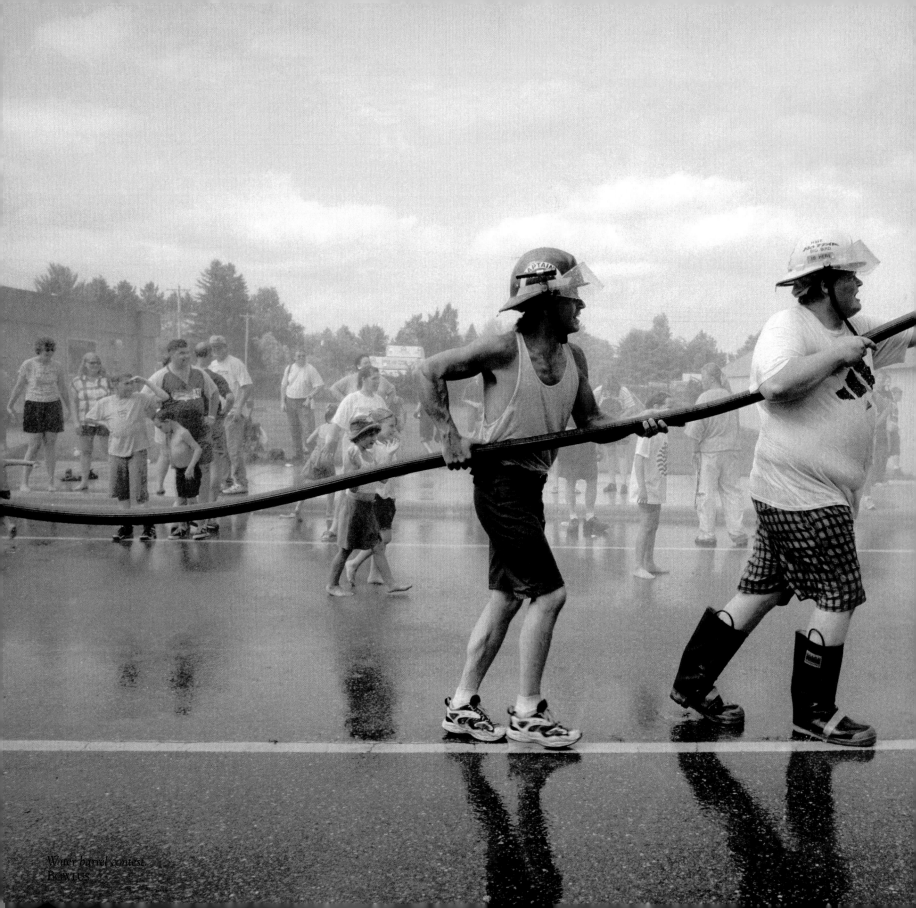

Water barrel contest.
BOWLUS

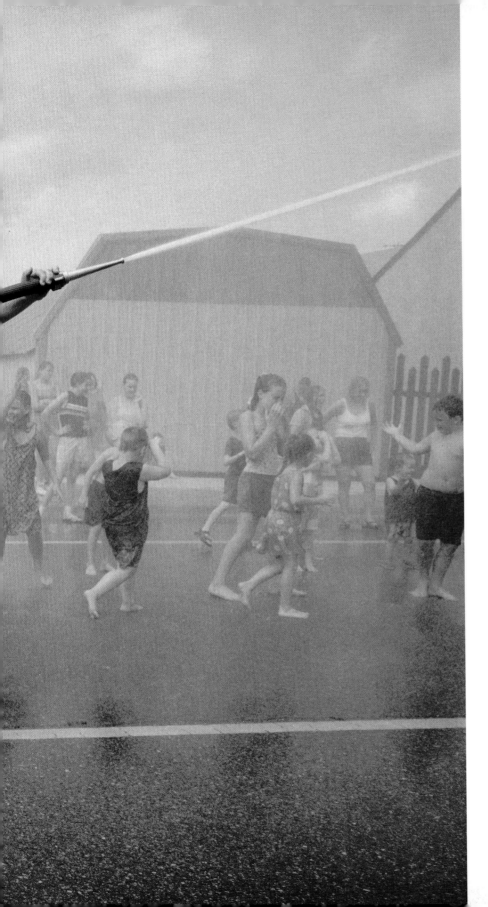

In Search of Lake Wobegon

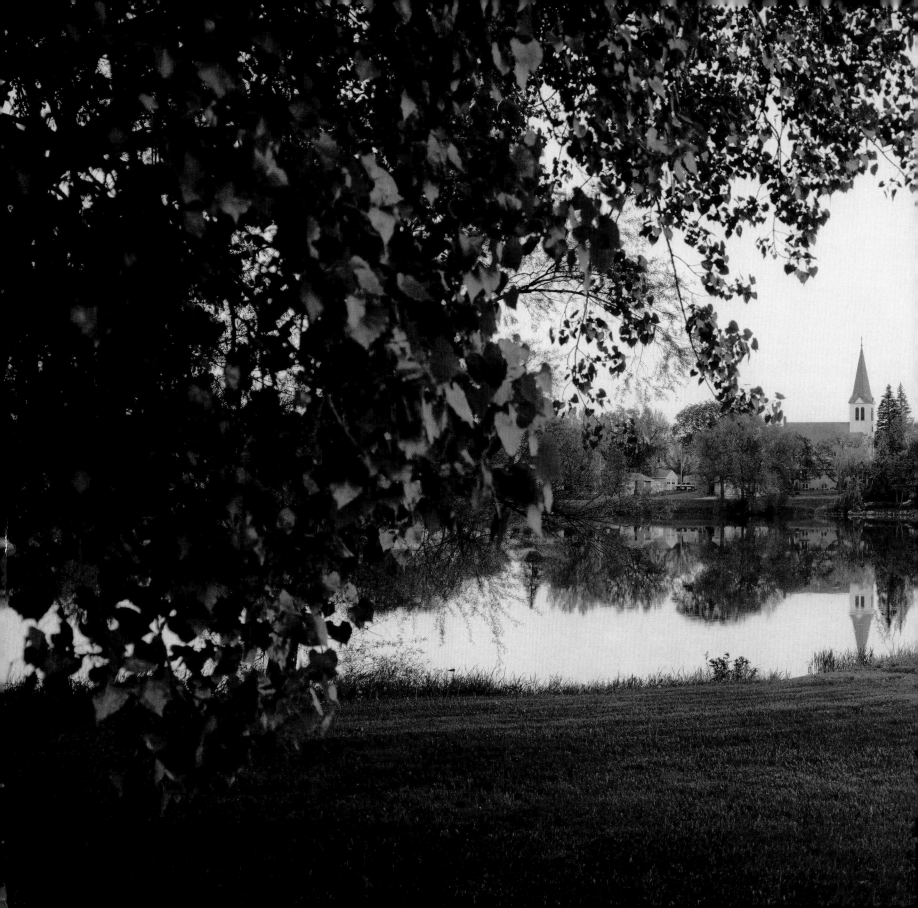

GARRISON KEILLOR

In Search of Lake Wobegon

PHOTOGRAPHS BY RICHARD OLSENIUS

VIKING STUDIO

VIKING STUDIO
Published by the Penguin Group
Penguin Putnam Inc., 375 Hudson Street,
New York, New York 10014, USA
http://www.penguinputnam.com

Penguin Books Ltd, 27 Wrights Lane,
London W8 5TZ, England

Penguin Books Australia Ltd, Ringwood,
Victoria, Australia

Penguin Books Canada Ltd, 10 Alcorn Avenue,
Toronto, Ontario, Canada M4V 3B2

Penguin Books (N.Z.) Ltd, 182-190 Wairau Road,
Auckland 10, New Zealand

Penguin Books Ltd, Registered Offices:
Harmondsworth, Middlesex, England

First published in 2001 by Viking Studio,
a member of Penguin Putnam Inc.

10 9 8 7 6 5 4 3 2 1

Text copyright © Garrison Keillor, 2001
Photographs copyright © Richard Olsenius, 2001
All rights reserved

"In Search of Lake Wobegon," in somewhat different form, and accompanied
by some of the photographs in this book, first appeared as an article with
the same title in *National Geographic*, issue of December 2000.

CIP data available
ISBN 0-670-03037-6

Printed in Willard, Ohio, USA

Designed by Mimi Park, Design Park Inc. Stillwater, NJ

Set in Goudy Oldstyle

The author and photographer thank all of the people of Stearns
County who let themselves be photographed and interviewed and
our researchers, Vicky Ducheneaux and Russell Ringsak and
Kay Gornick, and especially Bill Allen and Oliver Payne and
Kent Kobersteen of National Geographic for their patient
support. Many of the photographs and most of the essay originally
appeared in the magazine, a copy of which came into the hands of
a young woman in Stearns County, who looked at it and said, "I
recognize everybody in the pictures, but who is Garrison Keillor?"

WITHOUT LIMITING THE RIGHTS UNDER COPYRIGHT RESERVED ABOVE, NO PART OF THIS PUBLICATION MAY BE REPRODUCED, STORED IN OR INTRODUCED INTO A RETRIEVAL SYSTEM, OR TRANSMITTED, IN ANY FORM
OR BY ANY MEANS (ELECTRONIC, MECHANICAL, PHOTO- COPYING, RECORDING OR OTHERWISE), WITHOUT THE PRIOR WRITTEN PERMISSION OF BOTH THE COPYRIGHT OWNER AND THE ABOVE PUBLISHER OF THIS BOOK.

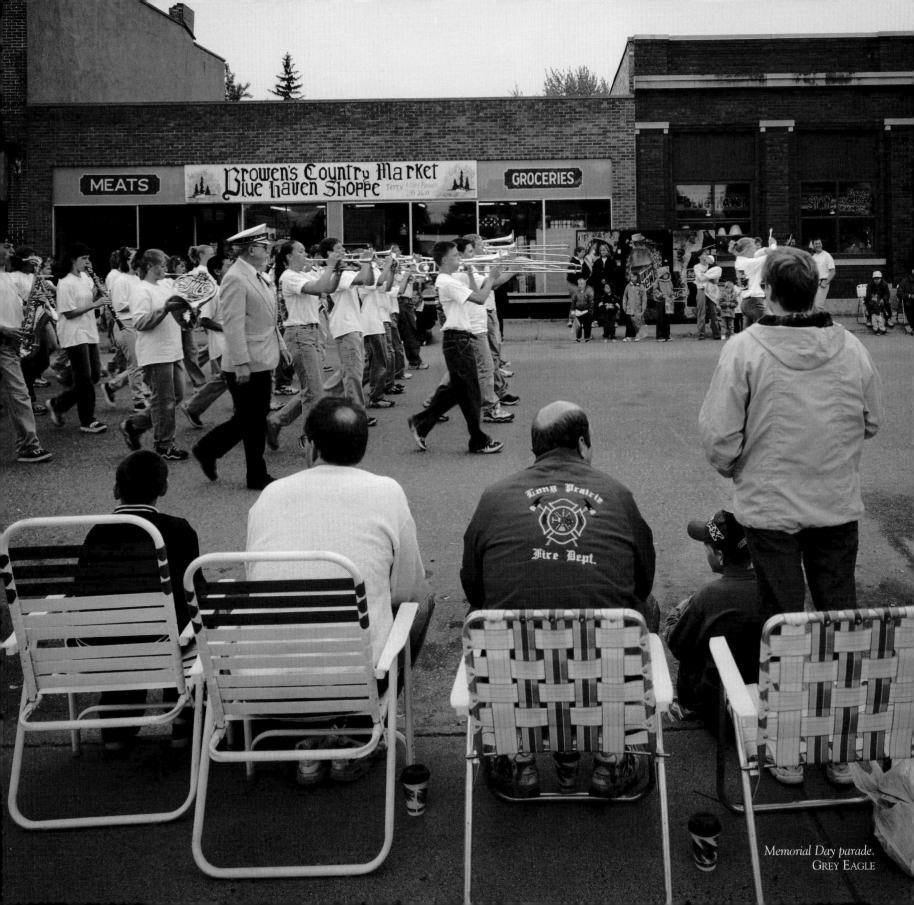

Memorial Day parade.
GREY EAGLE

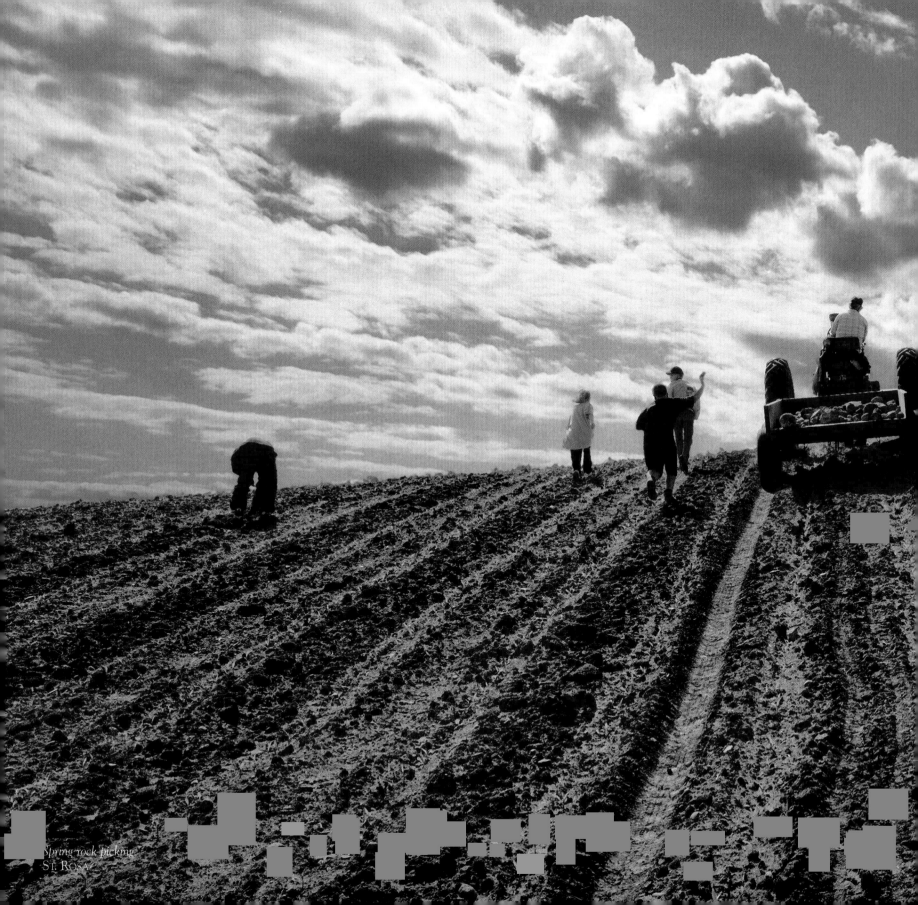

Spring rock picking
St. Rosa

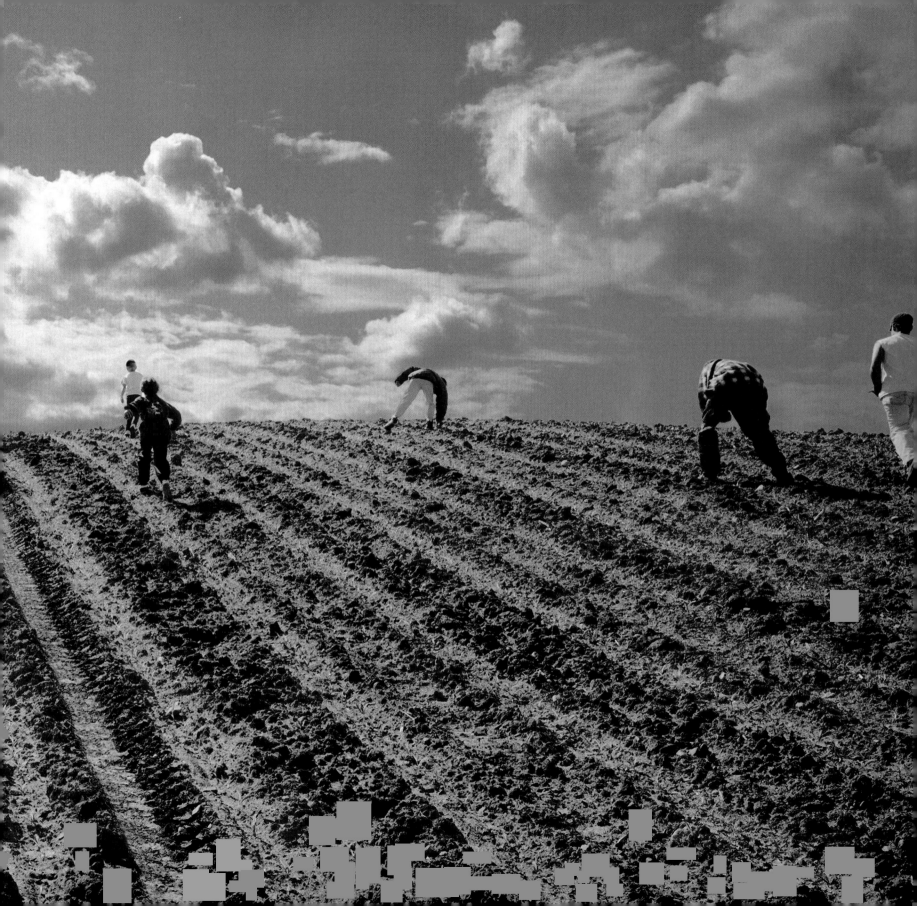

TWENTY-FIVE YEARS AGO, for amusement, I invented a small town where the women are strong and the men good-looking and the children all above average, and started telling stories about it on the radio in Minnesota, and ever since then, people have asked me if it's a real town, and if it is, then where is it?

I used to tell them that it's fiction. "Oh," they said. "Sure." But they were disappointed. People want stories to be true. The greater your gifts of invention or your ear for dialogue, the more they want your little lies to be based on real folks. They say, "That story of yours reminded me of people I knew when I was growing up in Iowa." They want you to tell them, "The character of Darlene is based about 95 percent on my cousin Charlotte. I only changed the hair from auburn to blond and made her more chesty." So I started telling people that the town is in central Minnesota, near Stearns County, up around Holdingford, not far from St. Rosa and Albany and Freeport, northwest of St. Cloud, which is sort of the truth, I guess.

Thirty years ago, I lived in Stearns County with my wife and little boy in a rented farmhouse south of Freeport, an area of nose-to-the-grindstone German Catholics proud of their redneck reputation. We moved there so we could live cheaply—I was supporting us by writing fiction for *The New Yorker*—and we found a big brick house on the Hoppe farm in Oak Township that rented for eighty dollars a month. With the house came a half acre we could plant in vegetables. It was a fine snug house, four rooms down, four rooms up, a mansion by our standards. A room for Mary's piano and a room for my Underwood typewriter and a small back room for the baby and two guest rooms for our writer friends from the city who liked to come and soak up the quiet and drink beer at night on the porch and lie on the lawn and look up at the stars. To the north of the house was a dense grove of spruce and oak where we got our firewood, and beyond this windbreak were a couple hundred acres of corn. Cows stood in a nearby meadow and studied us. The Sauk River was nearby, to canoe on, and Lake Watab to swim in. It was a land of well-tended hog and dairy farms on rolling land punctuated by tidy little towns, each one with a ballpark, two or three taverns, and an imposing Catholic church, and a cemetery behind it where people named Schrupps, Wendelschafer, Frauendienst, Schoppenhorst, and Stuedemann lay

shoulder to shoulder. There were no Keillors for miles.

For three years, I sat in my room and wrote short fiction and shipped it to New York. After a shipment, after a week or so, I'd watch for the mailman every day with more and more interest. He came around 1:30. I'd walk out the driveway to the mailbox and look for an envelope from *The New Yorker*—a large gray envelope meant rejection, a small creamy one meant acceptance. Acceptance meant another three months' grace. Eventually I ran out of grace and we moved to the Cities and I went back to my radio job and a couple years later started *A Prairie Home Companion* and the Lake Wobegon saga.

When I invented Lake Wobegon, I stuck it in central Minnesota for the simple reason that I knew a little bit about it and also because my public radio listeners tended to be genteel folk who knew the scenic parts of Minnesota—the North Shore, the Boundary Waters, the Mississippi Valley—and knew nothing at all about Stearns County. This gave me a free hand to make things up.

I put Lake Wobegon (pop. 942) on the western shore of the lake, for the beautiful sunrises. I said it took its name from an Ojibway word that means "the place where we waited all day for you in the rain," and its slogan was "<u>Sumus quod sumus</u>" (We are who we are), and to the German Catholics I added, for dramatic interest,

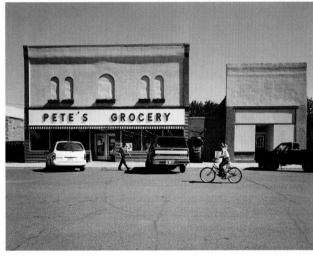

Downtown. WAVERLY

an equal number of Norwegian Lutherans. These don't exist in Stearns County but I bussed them in. The Norwegians, ever status conscious, vote Republican and the Germans vote Democratic to set themselves apart from the Norwegians. The Catholics worship at Our Lady of Perpetual Responsibility and the Lutherans at Lake Wobegon Lutheran Church (David Ingqvist, pastor), home of the 1978 National Lutheran Ushering Champions, the Herdsmen. On Sunday morning, everyone is in church, contemplating their sinful unworthiness, the Catholics contemplating the unworthiness of the Lutherans, the Lutherans the unworthiness of the Catholics, and then everyone goes home to a heavy dinner.

I F ANYONE ASKED WHY THE TOWN APPEARED ON NO MAPS, I explained that, when the state map was drawn after the Civil War, teams of surveyors worked their way in from the four outer corners and, arriving at the center, found they had surveyed more of Minnesota than there was room for between Wisconsin and the Dakotas, and so the corners had to be overlapped in the middle, and Lake Wobegon wound up on the bottom flap. (In fact, the geographic center of the state is north of there, in Crow Wing County, but never mind.)

Anyway, "*Gateway to Central Minnesota*" is the

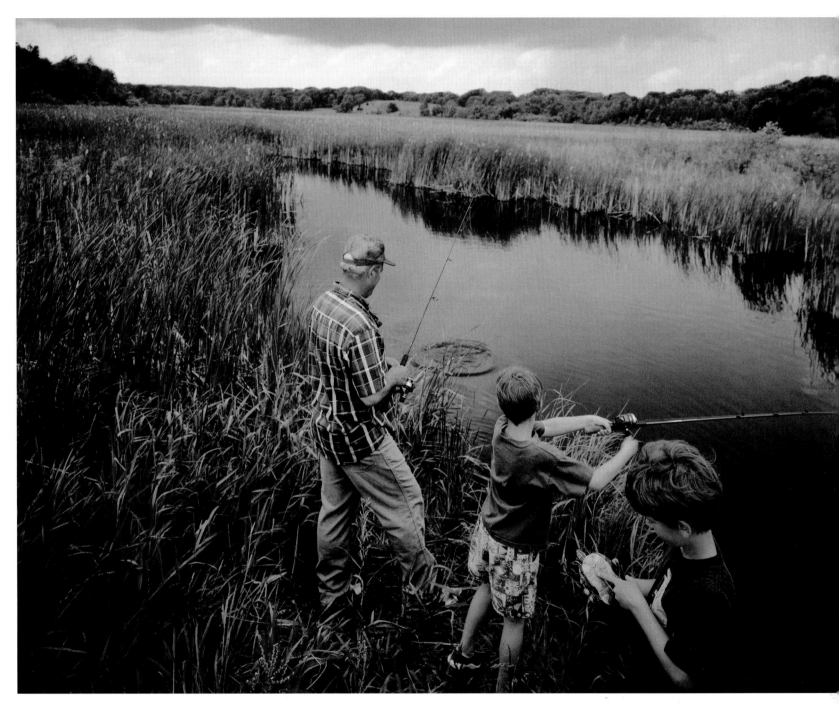

Roger Schmidt and his nephews, Travis and Alex, fishing on Lower Spunk Creek.

town slogan. And through the gateway over the years came a procession of characters. The three boys who drive to Iowa one February morning when they hear of Buddy Holly's plane crash and discover his blue guitar in the snowy field. The stolid Father Emil who said, in regard to abortion, "If you didn't want to go to Minneapolis, why did you get on the train?" and the town handyman Carl Krebsbach who repairs the repairs of the amateurs, and Bruno the fishing dog, and the irascible Art of Art's Baits and Night O'Rest motel, its premises studded with warning signs (DON'T CLEAN FISH HERE. USE YOUR BRAINS. THIS MEANS YOU!!!), and Dorothy of the Chatterbox Café and her softball-size caramel rolls (COFFEE 25¢, ALL MORNING 85¢, ALL DAY $1.25, ASK ABOUT OUR WEEKLY RATES), and Wally of the Sidetrack Tap, where old men sit and gradually come to love their fellow men through gradual self-medication. It was Wally's pontoon boat, the *Agnes D.*, on which the twenty-two Lutheran pastors crowded for a twilight cruise and weenie roast. When the grill capsized and hot coals swept the deck and the crowd shrank back and the *Agnes D.* pitched to starboard, they were plunged into five feet of water and stood quietly, heads uplifted, and waited for help to arrive. It's a town where the Lutherans all drive Fords bought from Clarence at Bunsen Motors and the Catholics all drive Chevies from Florian at Krebsbach Chevrolet. Florian is the guy who once forgot his wife at a truckstop. Her name is Myrtle.

The stories always start with the line "It's been a quiet week in Lake Wobegon" and then a glimpse of the weather. It's a fall day, geese flying south across a high blue sky, the air sweet and smoky, the woods in gorgeous colors not seen in Crayola boxes, or it's winter, snowflakes falling like little jewels from heaven, and you awake to a world of radiant grandeur, trees glittering, the beauty of grays, the bare limbs of trees penciled in against the sky, or it's spring, the tomatoes are sprouting in little trays of dirt on the kitchen counter, the tulips and crocuses, the yellow goldfinches arriving from Mexico, or it's summer, the gardens are booming along, the corn knee high, and a mountain range of black thunderclouds is piling up in the western sky. And then you go on to talk about Norwegian bachelor farmers sitting on the bench in front of Ralph's Pretty Good Grocery or the Chatterbox, where large phlegmatic people sit at the counter talking in their singsong accent. *So how you been then?* Oh, you know, not so bad, how's yourself, you keeping busy then? *Oh yeah, no rest for the wicked. You been fishing at all?* I was meaning to but I got too busy. How about yourself? *Nope. The wife's got me busy around the house, you know.* Yeah, I know how that goes.—And so forth. And you slip into your story, and take it around the turns and bring it to a point of rest, and say, "And that's the news from Lake Wobegon," and that's all there is to it.

MINNESOTA IS A STATE of decent hardworking people, half of whom live on the expanding island that is the Twin Cities, Minneapolis and St. Paul, an island of lifestyle in an ocean of cornfields and soybeans, where there is good espresso and Thai food and *The New York Times* and a couple orchestras and a dozen theaters and movie houses that show foreign and indie flicks and Ruminator Books has about three hundred shelf-feet of poetry and you can get almost anything people in New York or Los Angeles have and yet live on a quiet tree-lined street with a backyard and send your kids to public school.

Many folks live in the Cities who don't care for them much, regarding them as a sinkhole of crime and a hotbed of brainlessness. These are people who maybe used to say, "You couldn't *pay* me enough to live in Minneapolis" but they were wrong, money is persuasive. Nonetheless, they prefer the outskirts of the city and have found themselves a place of two or three or five or ten acres, what real estate agents call a ranchette or hobby farm, with room for a garden, a big yard, a dog kennel, a shed, a snowmobile, a satellite dish. So the cities of Minneapolis and St. Paul sprawl far out into farm country, the outer citizens commuting an hour or more each way so as to enjoy the illusion of rural life. There are trace elements of ranchettes all the way to St. Cloud, the Stearns County seat.

The eastern approach to Lake Wobegon is Division Street, St. Cloud, a five-mile strip of commerce in full riot, the fast-food discount multiplex warehouse cosmos adrift in its asphalt sea, the no-man's-land of twenty-four-hour gas stations that sell groceries and have copiers and the bright plastic restaurants where, if you ate lunch there for the rest of your life, you would never meet anybody you know or get to know anybody you meet, a tumult of architecture so cheap and gaudy and chaotic you wonder how many motorists in search of a drugstore and a bottle of aspirin wound up piling into a light pole, disoriented by flashing lights and signage and sheer free enterprise, and then the cosmos peters out and you emerge from hell and come into paradise, rural Minnesota.

The county appears to be prospering: population up 35 percent since 1970, new prefab industrial buildings cropping up along the main routes, trucks at the loading docks, forests of billboards as you approach Freeport and Avon and Albany. Avon (pop. 1033) even has what looks to be a suburb on the east side of town, the streets with suburbanite names like Angelfish Avenue, Barracuda, Char. The dairy farms seem to be getting along: new silos in evidence, the big hip-roofed barns look well kept, the cows themselves look professional, courteous, goal-oriented. Corn prices are low but farmers here raise corn only to feed cows and milk prices are still good enough to live on.

(One farmer told me that barns start falling apart if the cattle are evacuated; cows keep the temperature and humidity up and if they are sold off, the barn goes to pieces fairly quickly. A symbiotic relationship.)

You drive through the rolling fields, the valleys of little rivers, and every farmstead is different, some more formal, with white painted fences and all the buildings at right angles, others seem to have grown without much supervision and are strewn with old vehicles and historical artifacts of an appliance nature. Some are exposed, nearly treeless, and others you can barely see from the road, ensconced in a woodlot. Some have a dog that will take a run at you if you slow down.

There are major poultry operations in the county, vast prison camps of chickens, and a big mail-order outfit, and some big granite quarries around Cold Spring and Rockville, blasting out millions of cubic feet of rock every year. (West of Waite Park is a sign, BUY DIRECT/MONUMENTS, and an outdoor display of gravestones, dozens of them arranged as if in a cemetery but the faces are blank.) At the Rockville quarry, twenty-five-ton blocks of granite with striated grooves down the sides are stacked, including Rockville Beige and Diamond Pink, two local granites, and also Mesabi Black, and Lake Superior Green,

and black granite from Africa. There never was a Minnesota Granite Rush back when the rock was first discovered, it's too much work getting the stuff out of the ground. And I never mentioned quarrying in the Wobegon saga, because I don't know the first thing about it. I only talked about abandoned quarries where teenagers went to swim and drink beer and neck.

A county brochure claims eleven theater companies and music groups, but it doesn't mention the dozens of taverns and cafés which are the actual centers of culture here. Like Fisher's, an old supper club in Avon, where I once had men rolling around in the gravel parking lot, fighting over the fabulous Swenson sisters. Places with names like The Corner Bar, Sportsman's Bar, Tip Top,

Swany White Flour Mill. FREEPORT

or the Buckhorn, where gentlemen congregate for the purpose of enjoying a cold one and solving the problems of the world. They plant themselves in a booth, or lean against the bar, and they enact a classic four-character play: there's the Reader, who has come across an interesting item in the paper ("I read that, within five years, they'll have figured out how to throw a bunch of genetically engineered enzymes into a tank full of wet silage and turn it into milk"); and there's the Grouch, who maintains a dark view of human nature (". . . the big corporations are behind it because they want to clear out the little guys and put in ten-thousand acre farms"); the Worrier, always

a little nervous about something ("Genetic engineering or not, I just can't see things getting better anytime in the foreseeable future, I'll tell you that"); and the Big Fella, the guy who holds back until the topic is exhausted and then gives the final word ("People are not going to buy artificial milk. That's been proven. You can bet on it.").

They sit and hold forth on politics (corrupt, on both sides, always has been), global warming (hogwash), education (not what it used to be), women (can't live with 'em, can't live without 'em), exercise (when it's your time to go, you go, and you can run two miles a day and eat bran flakes and no animal fats and all you do is make a slimmer corpse) and take turns buying rounds, and if you happen to believe that mankind is on the verge of a new age of enlightenment and progress, these gentlemen will have a fine time pulling your chain.

Holdingford (pop. 635) is the town that looks most Wobegonic to me. It has a fine little downtown of elderly brick buildings and a big thriving grocery with a real butcher shop in the back and a classic four-legged cone-topped water tower, a graveyard full of big stones, and down by the river the Holdingford Mill, a jewellike assembly of galvanized-metal cylinders and boxes and slopes, and a faded old red boxcar on an abandoned siding.

I dropped into Mary's Family Restaurant, formerly the Rainbow Café, for coffee and oatmeal raisin cookies

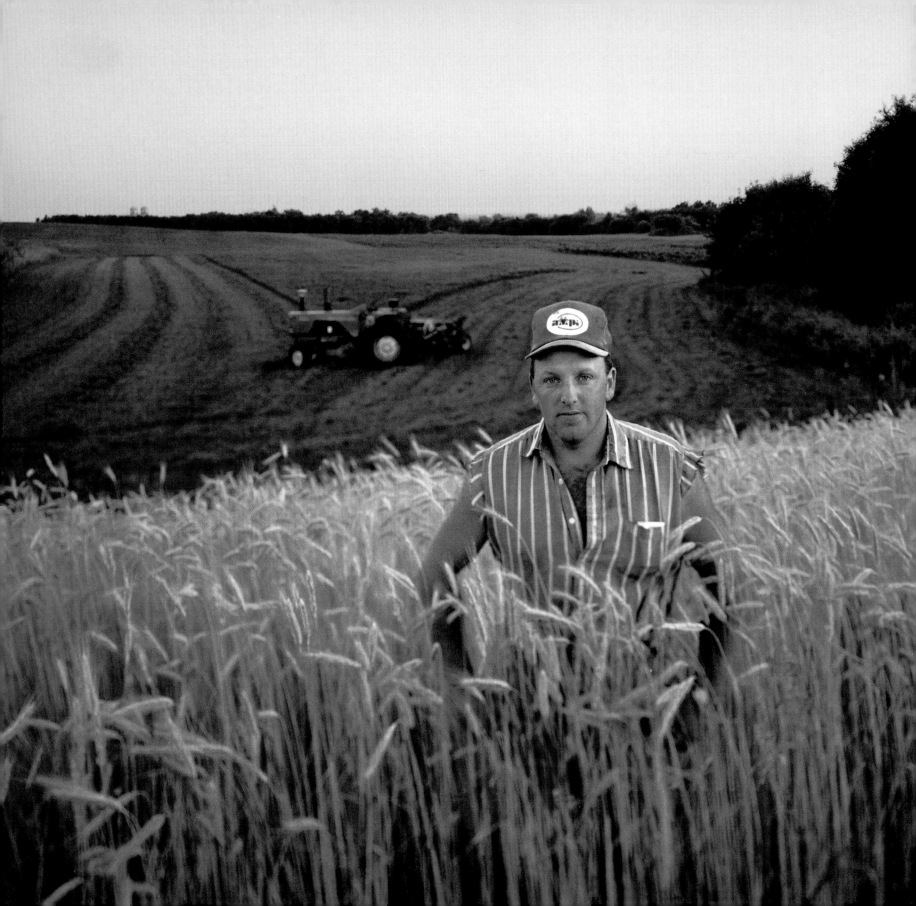

and listened to a fellow reminisce about the great Armistice Day blizzard of 1940. He was fourteen at the time and it made a big impression on him. They walked out of a second-story window onto the snow and dug a tunnel to the barn. He talked about logging up north and picking potatoes in North Dakota and earning a buck twenty-five a day. "Today everybody wants to make twenty bucks an hour and not do any work," he said. There were four of us at the counter and none of us disagreed with him: I myself would prefer to not do any work for much more than twenty bucks an hour.

New Munich was the town closest to the farm my family and I lived on. You drive in, past the sign (WEL-COME TO NEW MUNICH, HOME OF MUNICHFEST, which shows a dancing couple smiling, holding beers in their free hands), past Spinners Bar and Grill, the video store, the Munich Hofbrau, and come to the church, a big dramatic brick church trimmed in carved sandstone, with a bell tower, clock faces on all four sides, and magnificent heavy doors with big black hinges, a veritable cathedral in a town of only 314. Nothing about this modest village prepares you for the grandeur within—the inlaid tile floor and the high columns with figured capitals, the rose windows in the transepts, the lovely statues with the compassionate faces. I thought I had based Our Lady of Perpetual Responsibility on this church, but I could see that I didn't get the Baroque feel at all. Such a huge sanctuary, leaping arches, big organ and choir loft in the back, organ pipes, all illuminated by tall stained-glass windows: if I'd put it in Lake Wobegon, nobody would've believed it.

It's a county of many grand churches. There's St. Benedict's in Avon with its red roof and bell tower and St. Rose of Lima at the end of two rows of tall cedars in St.

Rosa, and The Seven Dolors in Albany, an orange-brick beauty that glows in the setting sun, and Sacred Heart in Freeport, a fine tall yellow-brick edifice with a high steep roof, but the church in New Munich stands out as a mighty architectural shout, a brick burst of exuberance, meant to astonish farmers and shopkeepers for all time.

Big churches, ballrooms, ballparks. From a hilltop in Millwood Township, you can see 6 steeples (and 110 silos). Long after the last ballroom in Minneapolis was demolished, Stearns countians trotted off to polka and schottische on Saturday nights, and then on Sunday afternoons in summer, they turned out at the ballpark to watch town team baseball. Even a tiny town like Meire Grove (pop. 139) fields a team.

Freeport calls itself the Dairy Center of the World, and in Charlie's Cafe, the cook does not stint on dairy products: the meringue pies are big enough to be bowling trophies. I had a grilled cheese sandwich, a bowl of chili, and a slab of banana meringue pie, and felt my belt and collar tightening. I got up and walked along the main drag. I saw an old man walk out of the post office who reminded me of Senator K. Thorvaldson, a man in a brown porkpie hat and pale blue polyester suit and green plaid shirt with a string tie with an agate on the clasp and wearing white shoes.

Freeport was a railroad town and the tracks ran along the south side of Main Street, and now the tracks are gone, and the one-sided Main Street remains, like an architect's rendering. Across the tracks is the Swany White Flour Rolling Mill, a yellow-brick structure on a heavy stone base, humming with machinery, V-belts moving on a pulley shaft, moaning, in a marvelous dim Rembrandt light, everything covered with cream-colored

Randy Gertken in a field of winter wheat—alfalfa field beyond.
NEAR FARMING

dust. They grind oats, rye, barley, soybeans, or rice here on five beautiful old enameled maroon rolling machines. It feels like the engine room of an old wooden ship or a giant wooden music box. It's been there for a hundred years. Amazing to think that I'd lived near Freeport and never thought to go inside.

Down the street is the Pioneer Inn. The Sidetrack Tap was modeled after it, a gloomy smoke-filled sour-smelling tavern, cluttered with neon beer signs and deer heads and funny mottoes, but the Pioneer Inn has been cleaned up, remodeled, the smells expunged. A few guys at the bar were talking about fishing and the lottery, neither of which was paying off very well lately. One of them said that Watab Lake, east of there, is 180 feet deep and home to some mighty pugnacious fish, none of which he had caught lately.

Being there, drinking a beer, looking down the bar toward the others, fifteen feet away, brought back a sudden clear memory of sitting in the very same spot, at the same distance, overhearing men talk, in 1970, and wishing I knew how to join that conversation.

Nobody ever welcomed us to town when we came in 1970. No minister visited to encourage us to worship on Sunday, no neighbor dropped in with a plate of brownies. Several times, I stopped at neighboring farms to say hello and announce our presence, and was met by the farmer, and we spent an uncomfortable few minutes standing beside my car, making small talk about the weather, studying the ground, me waiting to be invited into the house, him waiting for me to go away, until finally I went away. In town, the shopkeepers and the man at the garage were cordial, of course, but if I said hello to someone on the street, he looked at the sidewalk and passed in silence. I lived south of Freeport for three years and never managed to have a conversation with anyone in the town. I didn't have long hair or a beard, didn't dress oddly or do wild things, and it troubled me. I felt like a criminal.

This fear of outsiders was explained to me years later by a Stearns exile who said that the German population was so traumatized, first by the anti-Teutonic fevers of World War I that forbade the teaching of their language in schools, then by Prohibition that made outlaws of decent upstanding beer drinkers, that they never could trust *auslanders* again. A strange face is, to them, a cruel face. My German neighbors were a closed community and I wasn't in it. Proximity does not equal membership.

I ACCEPTED THAT, BECAUSE I COME FROM SIMILAR PEOPLE. Mine were Protestant fundamentalists, who lived by the Word and not by the opinion of others, and were wary of strangers, and didn't go for small talk. We were taciturn people who could sit in silence for long stretches and not feel uncomfortable. If strangers came to the door, they were dealt with and sent on their way. They were not people of the Word, and their friendship meant nothing to us.

As I sat in the Pioneer Inn and recalled the years I spent in Stearns County, it dawned on me where Lake Wobegon had come from. All those omniscient-narrator stories about small-town people came from a guy sitting alone at the end of a bar, drinking a beer, who didn't know anything about anything going on around him. Stories about prodigals welcomed home, outcasts brought into the circle, rebels forgiven: all from the guy at the end of the bar nursing a beer in silence. In three years, only one man ever walked fifteen feet to find out who I was—he

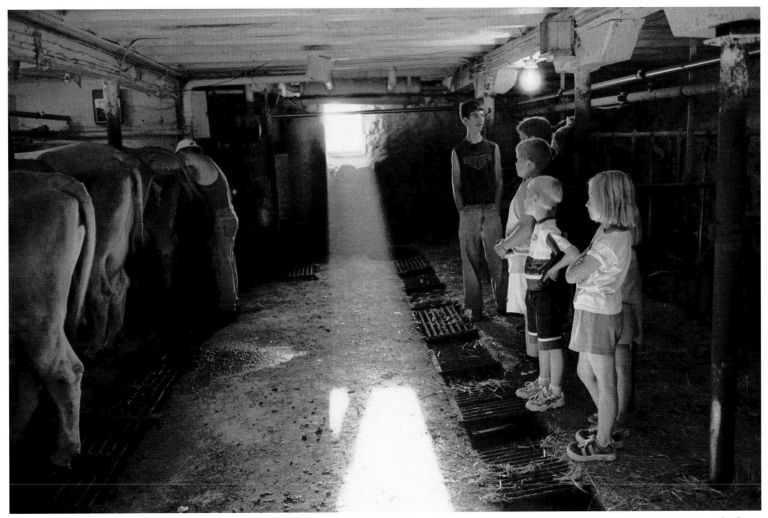

Children observing artificial insemination. ST. ROSA

walked over and said, "You live out there on the Hoppe place, don't you?" I said that, yes, I did and he nodded, satisfied that now he had me properly placed, and turned without another word and moseyed back to the herd. There was nothing more to say. He had no further curiosity about me, where I came from, or what I did out at the Hoppe farm, or if he did, he felt that a conversation with me might lead to expectations on my part, might lead to my dropping in at his place for more conversation, perhaps asking to borrow his pickup or inviting him and his family to dinner, a whole unnecessary entanglement. So he walked away. It kind of broke my heart a little.

I'd been away from country people for a while and was under the illusion that they're hospitable and

outgoing, and they're not. It's not that they're bad people. They are good Christian people, the soul of kindness. There is a hand-woven net of kindness in all of these little towns and people looking out for other people, visiting the sick, caring for the sick child so the mom can go to work, inviting the widowed for supper, bringing food to the elderly, giving rides, driving the old folks to Florida in January and flying down to drive them back home in April, coaching the teams and helping out at church and with Boy Scouts and Girl Scouts and 4-H, daily acts of kindness. Everyone is generous to those in need, except to those in need of conversation, especially if you're not from here.

Waiting for the band, Pelican Lake Ballroom. PELICAN LAKE

like a beggar. He can overhear the talk and it's about farming, of course, and hunting and trucks, and he has nothing to offer here. He goes back home to his typewriter and invents characters who look like the guys in the bar, but who talk about all sorts of things that he knows about, and soon he has replaced the entire town of Freeport with an invented town of which he is the mayor, the fire chief, the priest, the physician, and the Creator Himself, and he gets a radio show and through perseverance and dumb luck and a certain facility, the fictional town becomes more famous than the real town, and now when he goes to Freeport, some people come up and say, "You're Garrison Keillor, aren't you?" A person could write a novel about this.

So I INVENTED A TOWN WITH A BAR IN WHICH, if a stranger enters, he always turns out to have an interesting story. The stories were my way of walking fifteen feet and joining the circle. I had to invent a town in order to be accepted, like the imaginary friend I had in second grade, David, who walked to school with me.

The loner nursing his beer at the end of the bar is starved for company. He has little to say to his wife, who is depressed and has little to say to him. In the long shadows of a cold winter night, anxious about money, in dire need of society, he drives five miles to town and sits at the bar, where his pride and social ineptitude get in the way: he has no idea how to traverse those fifteen feet without feeling

Some MINNESOTANS LIKE TO THINK of the state as multicultural and youthful and plugged-in and the home of the Mall of America and look on Lake Wobegon as a vanished culture, but those people aren't very smart. True, the world looks a little different today than in my childhood, but culture is not superficial. You don't acquire it by reading *The New Yorker* and learning about wines and redoing your living room in Southwestern with cowhide chairs and Navajo blankets.

Culture isn't decor, it's what you know before you're twelve. It sticks with you all your born days. The

apple doesn't fall far from the tree. You can try to wrestle free of it, like those geese who trail the V-formation, trying to look as if they aren't part of this bunch, as if flying south were a personal decision on their part, but your feint toward independence only makes it clearer who you really are. Some people like hot dish better if it's called cassoulet, or pot roast if it's pot-au-feu. Fine. Suit yourself. Same difference.

Certain bedrock principles unite Wobegonians, even those trying to wrestle free and those in exile, which most of us are.

Number One: We weren't brought up to expect happiness. We are surprised if we do well in the world. Outright success astonishes us. We maintain a dark fatalistic streak, especially in the midst of prosperity. In the bullish nineties, many Wobegonians resisted the temptation of easy money in the stock market, resisted it resolutely for years, until finally, weakened by all those stories about mutual funds that earned you 20 percent or 30 percent a year, they took the plunge, just in time for the market to go in the toilet, which, of course, is exactly what we expected all along. We are dark people. If you offered us a drug with no side effects that would make us happy every single day, some of us would turn this down on principle. Don't ask me why.

A corollary of this darkness is our great reluctance to express personal preference.

Let's go out to eat tonight.—Whatever you want.—Well, what do you want?—Anything is fine by me.—You want to go out then?—Either way. Suit yourself.—Where do you want to go?—Wherever you like.— This litany is basic to us. If you express strong preference, you're saying something about pleasure being rational— I like the chicken at Fisher's Supper Club and, therefore, if we go to Fisher's, it will cause me happiness—and we know this can't be true. It *might* be nice if you roped me into going to Fisher's, but if I myself chose this, we would arrive at Fisher's and sit down to the table and suddenly a black cloud would settle over us. The necessity of happiness once one has made one's choice is too much to bear. So surprise me. Put me in the car and drive me to Fisher's and let me protest that I don't need to go, that I'd rather go where you want to go. And then probably I'll be happy. But who knows? I could also suffer a cerebral hemorrhage and be hauled away to the hospital before the condiments arrive.

For us, work is no problem, vacationing is the hard part. Where do you go? And why? We're not a romantic lot. *La Bohème* wasn't written here or *Les Sylphides*; bellbottoms didn't originate here, or lava lamps, Elvis was not one of ours, flaming desserts aren't native to here or Mardi Gras. We enjoy these things, occasionally, with a certain sense of irony, but they're not us. We take a dim view of frivolity and excess. We're minimalists. We abhor flattery. Even sincere praise troubles our conscience. What's wrong with that?

Wobegonians grew up learning to be useful. You may not set the world on fire but you should be good at something. Do your work. Pull your weight. Don't be some arrogant blowhard who's all gas and no flame. Be helpful while you're at it. Don't pass by people in trouble and pretend you don't see them. Stop and give them a

start with your jumper cables. Put some money in the beggar's cup. Buy the fruit basket from the Boy Scouts. Everybody in town does day care; whoever is closest sees to the kids, no matter whose they are, and yells at them to get out of the street and stop throwing stones.

We are a people of laws. Mind your manners. Keep a civil tongue. Be cheerful. Avoid self-pity. Don't complain too much about the cold because other people are cold too, winter is not a personal experience.

Winter is crucial. It's what makes us different from other people and from what we know of other people, we are grateful for this. Winter keeps them out. As it is, we get a few of those people coming here, but if we didn't have winter, we'd be so overrun with other people, we'd become other people ourselves. And everyone knows that hot weather is not conducive to intelligence. Look at Texas.

MY LOYALTY TO LAKE WOBEGON is to all the people I might've gone to school with. All of us sitting at rows of desks, our hair combed, our hands folded, Washington and Lincoln looking down at us, and I am happy to be in this bunch. Not the beautiful people, not necessarily gifted either, but hopeful and so eager to please, anxious to be good and to uphold the honor of the school. I have run into such in Rome and London and Copenhagen and New York and swiftly recognized them as belonging to my tribe and broke bread and drank coffee with them and even without speaking we knew each other, knew each other's dark thoughts and good principles, and enjoyed each other's silence.

We have a cranky streak in us, inherited from our ancestors, many of whom came over from the Old Coun-

try for no better reason than that they just plain didn't get along. They believed that life is a vale of sorrow, due to the fact that most people don't have the brains that God gave geese. Life is treacherous. You tear out your back steps to put in a patio and you wind up cracking the line to the septic tank and suddenly the toilets overflow and you're facing huge plumbing bills, all because you envisioned sitting on a chaise longue and sipping cold beer. Silly you. A man quits drinking and after a few months of sobriety everyone realizes that down deep, whiskey or no whiskey, he really was a jerk. Now what do you do with him? You want to go to college and become a writer? Well, good luck. People in hell want ice water.

Childhood is over early in Lake Wobegon and when it's done, it's done, and it's time to pack up and get out and make a life. Those people on daytime TV talking about how their parents never gave them the positive feedback they needed and that's why they shot them— those are not our people. The folks holding hands in a circle in the redwood grove at sunrise while someone plays a flute and a tall desiccated lady with a little O of a mouth reads a poem about water flowing over stones— it's not us.

They are herbivores and we're carnivores. We eat flesh. We overcook it to get the red out, and when we see blood, we call it juice. But we eat Babe and Bambi and Mary's little lamb. We are carnivores because we've noticed that predators are a good deal smarter than grazing animals. If you've ever been around sheep, you know this. Centuries of munching on grass have not honed their intelligence much, whereas coyotes or wolves or cougars have almost evolved to where they could get into law school.

We Wobegonians grew up in a Christian culture, and absorbed it even if we weren't regulars on Sunday. We learned long before we were twelve that God loves us but God also says hard things that a person doesn't care to hear. We heard about Noah's Ark, which is not an easy or comforting story, and neither is Abraham and Isaac. We heard the story of the Prodigal Son and it's hard too, if you imagine yourself as the faithful older son, which we do.

Some people feel that every time they are good to themselves, it's a religious act, but that's not us. That's the Church of the Brunch, conducted over croissants and a nice Sauvignon Blanc. We are not of that church, pleasant as the liturgy may be.

There are all sorts in Lake Wobegon, there are painfully shy people and people who will stop you on the street and tell you their life story, people with a mean streak and people of consummate kindness and good humor, but there is a natural committee instinct here. You invite people for dinner, and they ask, "What can I bring?" The spirit of potluck prevails: you bring the rolls, they bring the salad, she brings dessert, and we'll each bring a hot dish. The Julia Child model of the heroic cook working forty-eight hours in advance, marinating, trussing, tying up fresh marjoram in cheesecloth, peeling and deseeding the tomatoes, blanching the almonds— that isn't how we do it. Lake Wobegon is the land of the

Jim Lauer running the baler with his children, Rebecca and Daniel.
NEAR ALBANY

hot dish, the land of Good Enough. You really want to spend three hours making that fancy recipe with goose and lamb? No, no, no. Take the navy beans and chop up some wieners and put in ketchup with Worcestershire and maybe some onion soup mix for flavor, and you've got it. It's good enough. Put the hay down where the goats can get it.

EGALITARIANISM IS ONE THING to like about Stearns County. They may look down on strangers, but they look down on all strangers, no matter what sort of car they drive, and that's better than looking down on people because they have less money, or do dirty work. And it has a real culture. It doesn't draw its identity from the media, it draws it up out of the past, like well water.

The media world is a small town of its own, and information is the currency—who's up, who's down, what's new, what's newer—but here the currency is character, as expressed in stories. So I made up stories about its character, morphing some of my old fundamentalist relatives into German Catholics.

I had a train pull up on a sidetrack in 1938 and an aging Babe Ruth step down and wave to the crowd. He was with the Sorbasol barnstorming team that played the local nine that afternoon and the Babe hit one so far it was never found again. The ballpark is still there. The Whippets play there, and in the spring, middle-aged men

who have smelled the April air come with a glove and throw a ball around.

Here beside the tracks is the foundation of an old grain elevator that, one Saturday night in the summer of 1940, as various couples sat and smoked and drank beer and necked in their cars along the train tracks, went up in a pillar of flame five hundred feet high, and people leaped from those cars and tore for cover and the churches were full on Sunday. Most of those couples married soon after and most of the marriages lasted. Not a true story, but when the thing blew up, it seemed real enough.

THE CEMETERY IN FREEPORT IS BEHIND THE CHURCH, but in Lake Wobegon I put it on a high hill, which Freeport doesn't have. It was there that Clarence Bunsen gave his famous Memorial Day address.

The VFW honor guard stood at parade rest in front of the monument to the Grand Army of the Republic, their feet hurt, their jackets were too tight, they needed a drink. The crowd stood on the grass. A boy recited:

Breathes there the man with soul so dead
Who never to himself hath said,
"This is my own, my native land."
Whose heart hath ne'er within him burned
As homeward his footsteps he hath turned
From wandring on some foreign strand.

THERE WAS A TREMENDOUS LONG SILENCE, and then Pastor Ingqvist gave a nod and after a moment Clarence stepped forward and hesitated and said, "If there was one time when words truly seemed inadequate, one occasion when silence seemed so appropriate, it would be here and now. It would be more fitting if we were silent for two minutes and looked around us and thought of our people here and their gifts to this country." He stepped back. Everyone looked around at the markers and the little flags fluttering and listened to the breeze in the leaves. An oriole sang. And then someone blew his nose. The whole honor guard was crying. Old men with rifles to their shoulders dug down in their pockets and got out their big red hankies and blew.

And afterward they pressed around Clarence and shook his hand and said that was absolutely perfect, they'd be grateful to him for the rest of their lives. He didn't think he needed to tell them that when Pastor Ingqvist nodded to him, he suddenly remembered that he was supposed to speak and a wave of guilt washed over him that he had forgotten Memorial Day, the day of remembrance, and he wanted to cry out "I am not worthy!" And then he felt steady again. "It's not about you," he thought. "You're not the reason they're here." And he stepped forward and said his piece.

I feel the same way about Stearns County and Lake Wobegon. It isn't about me. I find that if I leave out enough details in my stories, the listener will fill in the blanks with his or her own hometown, and if a Freeport girl exiled in Manhattan hears the story about Memorial Day, she'll put it right smack there in that cemetery with those names on the stones, and she may think of her uncle Alcuin who went to France and didn't return, and get out her hanky and blow. I'm not the reason she's moved, he is. All I do is say the words, *mother* and *blackboard* and *whiskey* and *outfield* and *rhubarb*, and other people put pictures to them. □

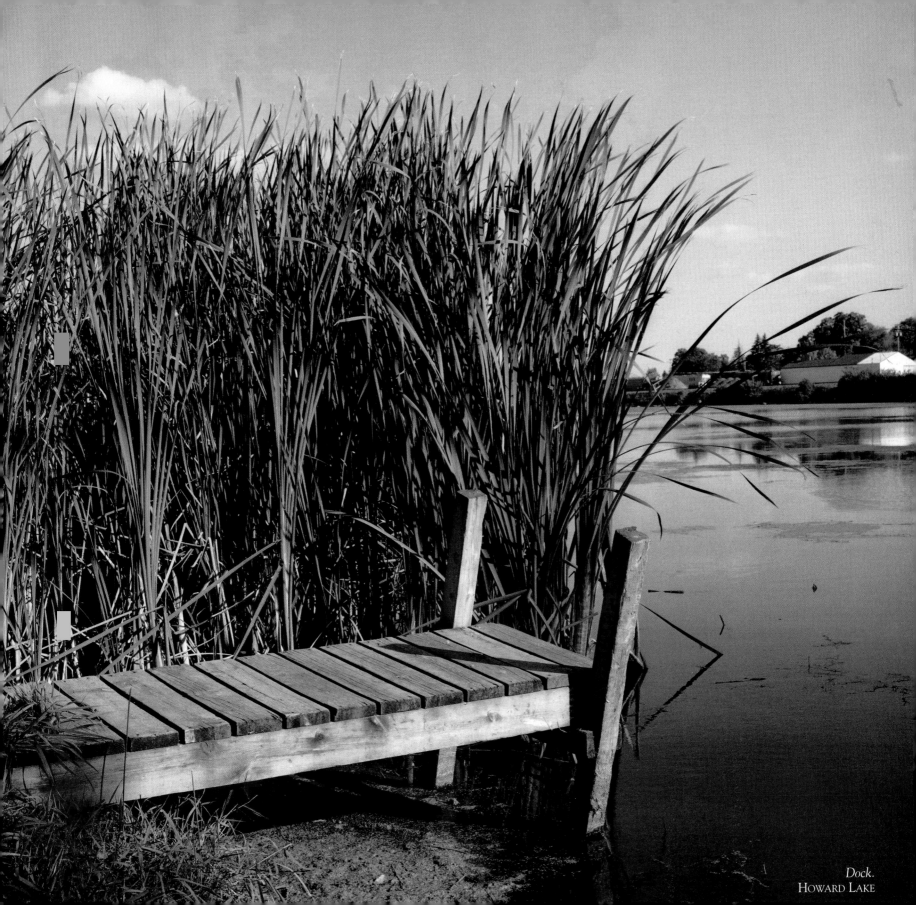

Dock.
HOWARD LAKE

In the middle, Cindy Scepaniak follows her altar boy sons, Bobby and Adam, and leads the girls in their white Communion dresses, carrying baskets of flowers, in the Corpus Christi procession on a May day at St. Mary's church in Holdingford, in a two-hour event with a sermon at beginning and end.

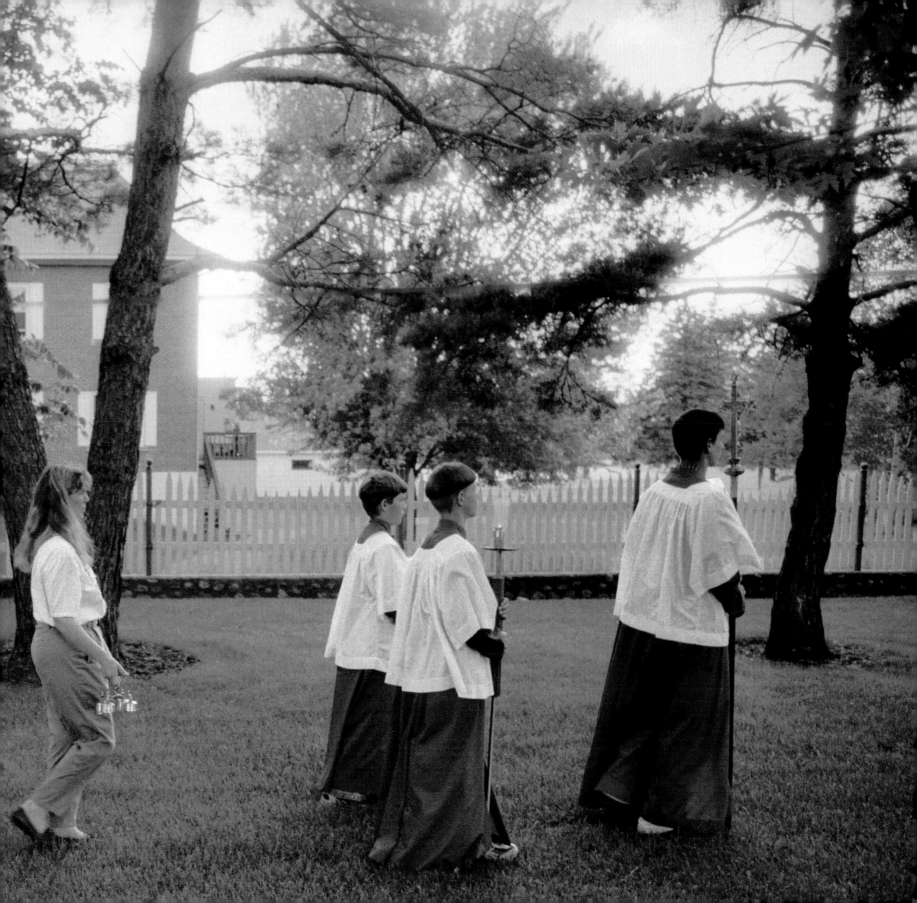

On a Friday afternoon in October, the Holdingford High School homecoming court poses in a pickup painted with Holstein markings. Queen Tanya Bieniek stands next to king Kyle McNeal, the 165-pound Huskers starting cornerback. Tanya: *It was fun that week. We stayed up late the night before at Crystal Wynnemer's house and slept over and got up and did each other's hair. The whole senior year was great, I was in swimming and yearbook (Holding Memories) and FFA. I'd been shy before and I was elected the Class Motor Mouth.* Kyle: *The football team had a pretty good season but we screwed up on our homecoming game. We were leading at halftime by two touchdowns and thought we had it and then we came back, and mentally we weren't there and we lost. The homecoming dance wasn't so happy. It was at the gym. There was a DJ and I danced with my girlfriend and we left early. The team was bummed about the game. But the whole week was, like, wow. Cool. I was in awe.* Tanya: *Our senior class was less than a hundred people and everyone knew each other. A lot of us got really close. It was a really great year. I took some woodworking classes and decided to become a carpenter. I want to build houses. I like framing up the walls. I've always liked pounding nails.*

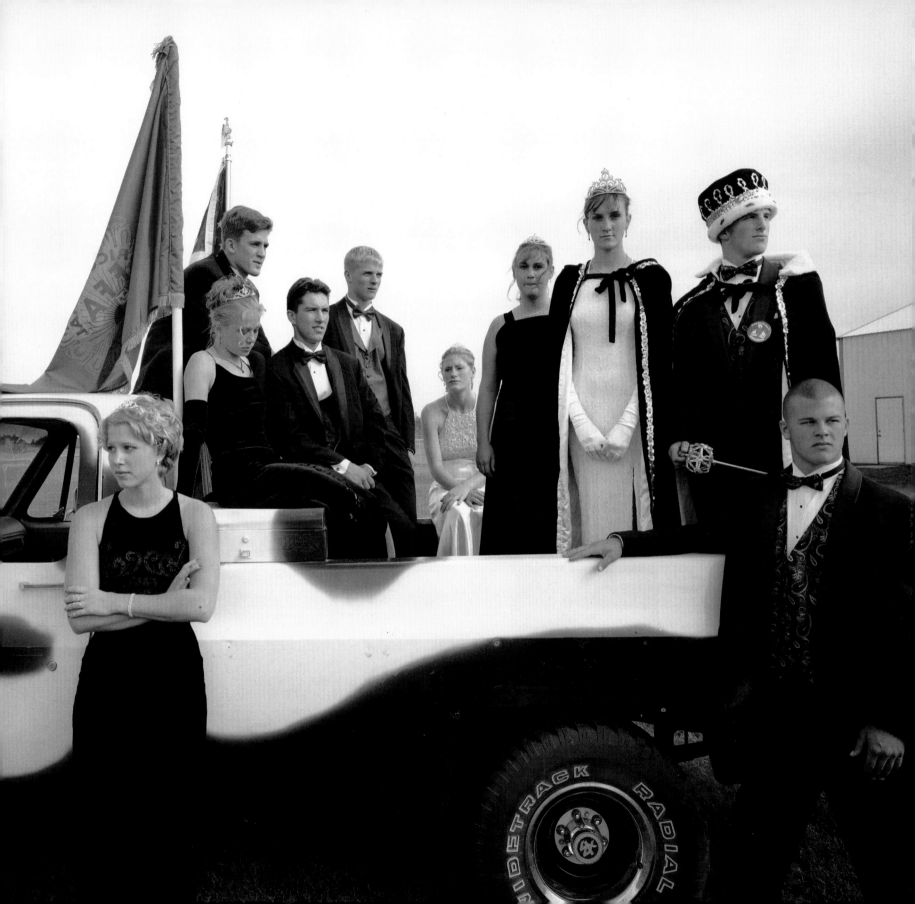

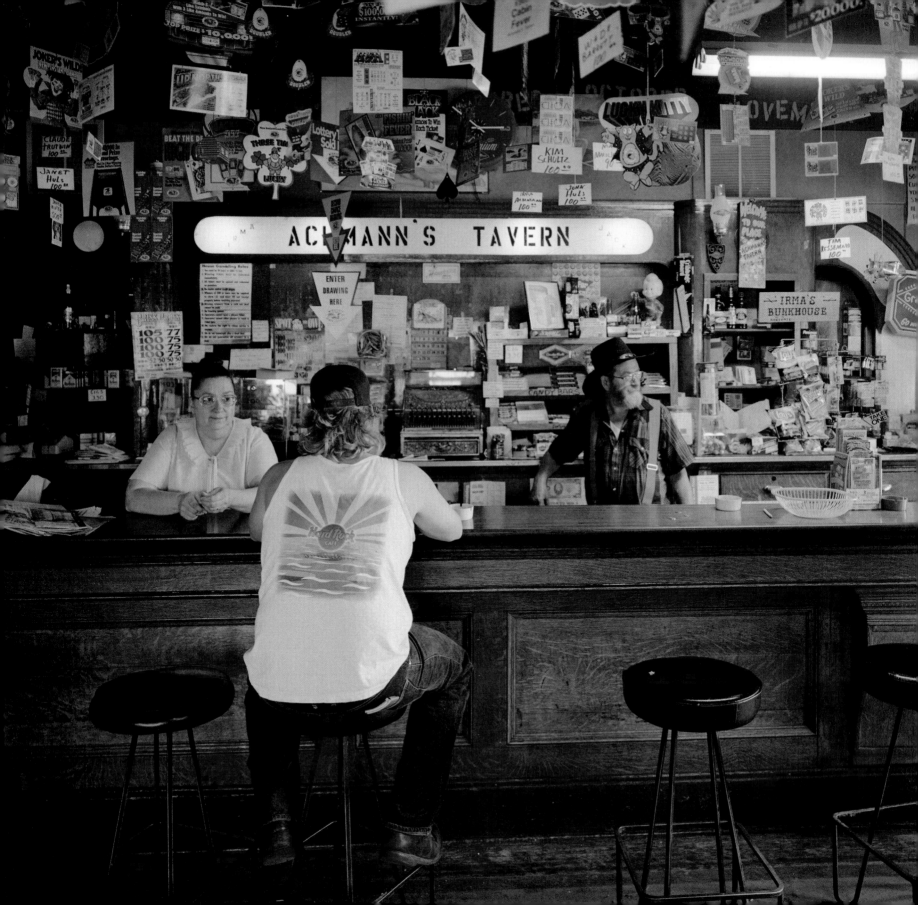

Men leaned on the bar, the dark oak scratched and gouged, their faces seamed and shadowy, talking about the death of Hansen's dog, the ugly one, the dog that bit Carl the time he slid his car in the ditch.

"The cinnamon colored dog," said Carl. "He bit me hard in the back of the leg. I'd gone up there to borrow a snow shovel and the dog bit me and Audrey says, 'What happened?' and I said, 'Your dog bit me!' and she says, 'That dog don't bite.' I said, 'Well, *some* dog bit me and he's the only dog here.' And the dog was being very cool about it, wagging his tail, smiling up at me, so I didn't say any more, I went and shoveled out the car. He was a terrible dog. He bit a lot of people. I think he bit Berge once in the butt, didn't he? Show us that, Berge."

"He never bit me," said Berge. "Dogs don't bite Norwegians, they know we're too salty and we've got too many bones."

"I decided to teach that dog not to bite, so a few weeks later I went up to Hansen's to borrow a posthole digger and Audrey sent me around to the tool shed, and in my pocket I had a couple chunks of sirloin and a plastic cup with two raw oysters in it. The dog was trotting along beside me and I flipped him a chunk of sirloin and then another chunk, and then I flipped him the raw oyster. He caught it in his mouth and as the oyster was going down, the dog was trying to spit it out—you ever see a dog do that? He was down on his knees, trying to stick his paw down his throat. I took the other oyster and rubbed it on his food dish so that he would think about oysters in the future. Then I told Audrey I changed my mind about the posthole digger, and I went home."

"So did the dog learn his lesson?" said John.

"I didn't go back to find out," said Carl. "Didn't see the Hansens for five or six years, though I recall that whenever I drove past there, that dog would chase me for almost a mile. He came running flat-out, his chin about an inch above the ground. A couple of times I clocked him at fifty miles an hour."

"I stopped telling lies because it's too complicated," said Mr. Berge. "You lie, and you have to remember what you said the first time. But I only gave it up recently. I could go back to it if I had to."

—*Lake Wobegon Boy*

Achmann's Tavern. ST. WENDEL

Luethmers Bar. ST. WENDEL

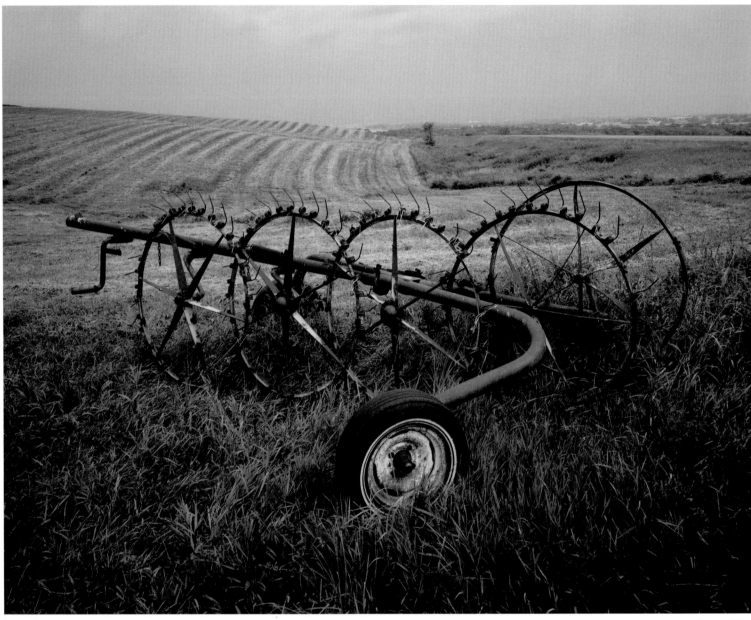

Hay rake.

SPRING HILL

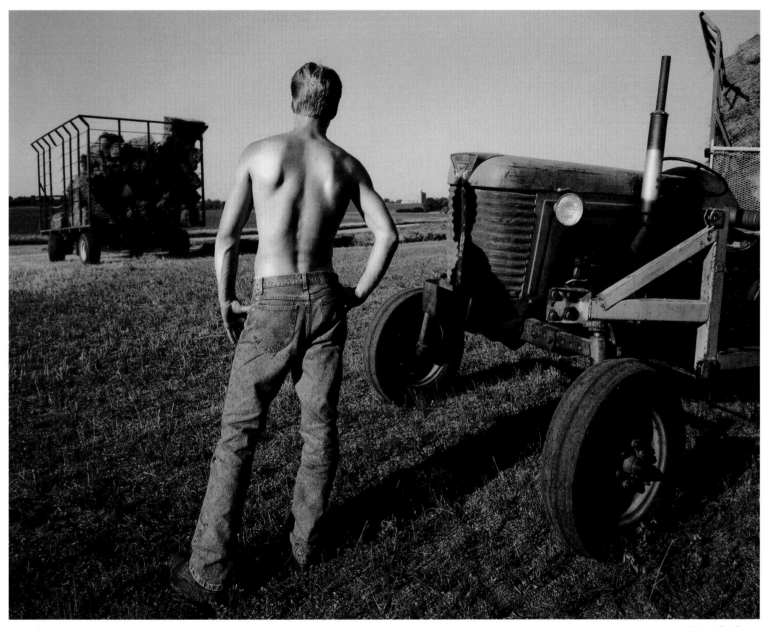

Second cutting.

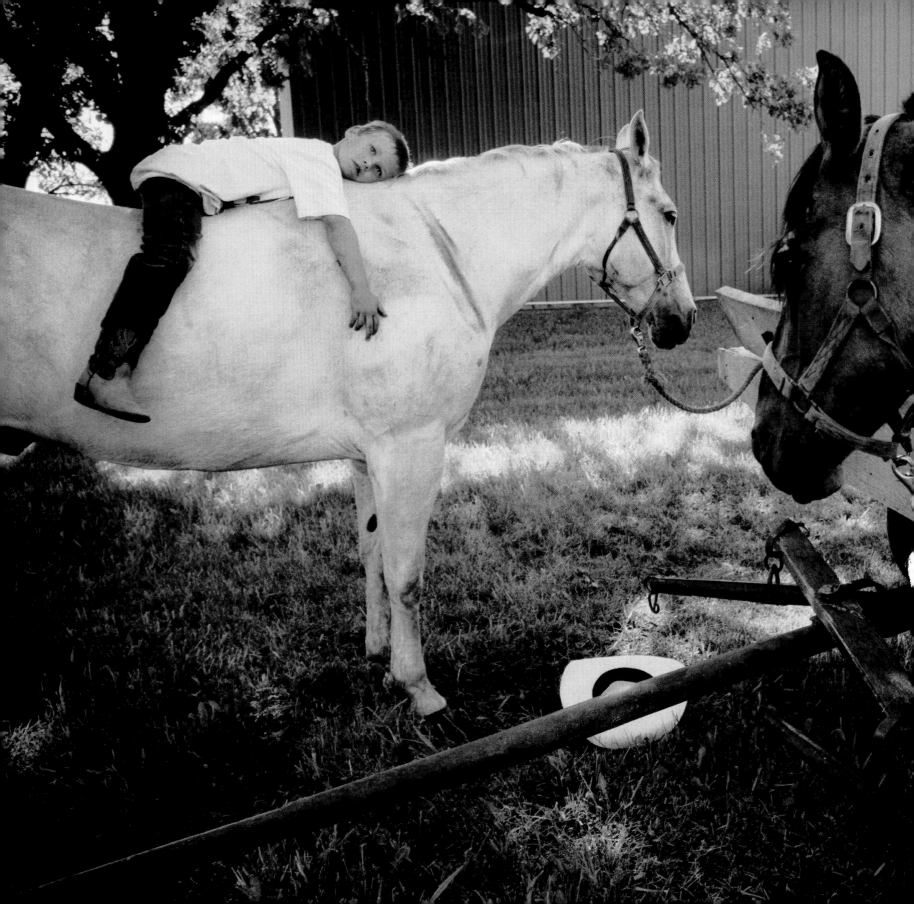

J ake Hinnenkamp stretches out on a white gelding, Vandy, outside
Linda B's bar and grill in St. Rosa. His folks, Darrell and Suzette,
had driven the team and wagon to town and were inside eating brats
and sauerkraut. *Darrell's from Melrose and I'm from Long Prairie. We
met horseback riding in Melrose. He was riding with his friends and I was
riding with mine and my friends turned out to be friends of his friends. I
was just learning to ride and he rode up alongside me and said, "I wonder
if your horse rides double." I said I didn't think so, and he swung over and
sat behind me. I didn't know what to do, so I just hung on. We live on ten
acres outside Melrose. We have six horses in all. We both work out. I work
at a woodcraft place down at Belgrade and Darrell works at Genex, which
makes silos. We lived in town before and we'd never move back. I like the
quietness. I like looking out the window and not be looking into someone
else's. Darrell's home place is just across the road from us. His brother is
farming it; he milks about fifty cows, Holsteins. That horse Vandy is very
tolerable with kids. Jake's been on him since he was about a month old, on
his first trail ride.*

Ronnie has been working as a short-order cook and helping his dad around the farm instead of going to St. Cloud State, which had been his plan, to go into some type of management, but that was before the run-in last March when he and his three best buddies decided to go ice fishing around midnight one Friday night, and Ronnie borrowed his dad's Winnebago. His folks were asleep, he didn't want to bother them, so they loaded beer and some food in it and headed out on the lake. As he drove out on the ice, it did strike him as odd that there were no fish houses out, but he was nineteen and with his friends and it was midnight. They cut a hole in the ice, and they had a merry night of fishing and drinking and Ronnie made a big pot of spaghetti and they caught about thirty sunnies and as the sun came up, one by one they crawled into the bunks of the Winnebago and went to sleep. About two in the afternoon, Ronnie heard honking. Someone in a pickup truck on shore was honking and waving. And then Ronnie saw open water in the middle of the lake, not that far from him. He was now completely awake. He started up the Winnebago and eased her away from the open water and toward the shore. His friends were asleep and he decided not to wake them up. It was a time to be calm. And then he saw open water straight ahead between him and the shore. He stopped and got out. The man onshore was pointing toward the open water a little farther downshore. He yelled, "It's shallower there. If you gun it, you can probably make it." So Ronnie backed up about two hundred yards and put the pedal to the metal and as the Winnebago hurtled forward over the ice, Ronnie remembered that the pot of spaghetti was still on the stove. Too late for that now. He hit the open water at 50 miles an hour and everything in the RV became airborne, the pot flew past him into the windshield, and the cabinets tore loose and his friends came hurtling out of the bunks and she hit the shore with the back wheels screaming and the transmission chewed itself into pieces, the rear axle broke, the tie rod, the frame twisted, and the Winnebago came to rest in the brush about fifty yards up the bank. Ronnie sat at the wheel. There was spaghetti all over the dashboard. Nobody was seriously hurt. One advantage of being drunk.

But the Winnebago was a pile of junk. The man waving his arms was Ronnie's uncle Al. He looked inside the Winnebago and it was all beer bottles and dead fish and broken plywood and tomato sauce. He said to Ronnie, "You need a ride home?"

Ronnie went home and told his dad, and discovered that the RV wasn't insured in the winter, only in the summer. It's at a moment like that, a young man gets to know his father in ways you wouldn't through hours of conversation. He didn't ask his friends to help and none of them offered. He's doing it himself. To meet your obligation and live up to your own code of honor is an education in itself. It's amazing what you can learn if you're lucky enough to get into trouble when you're young. —FROM "MOTHERS, FATHERS, UNCLES, AUNTS"

Dropped load. NEAR FREEPORT

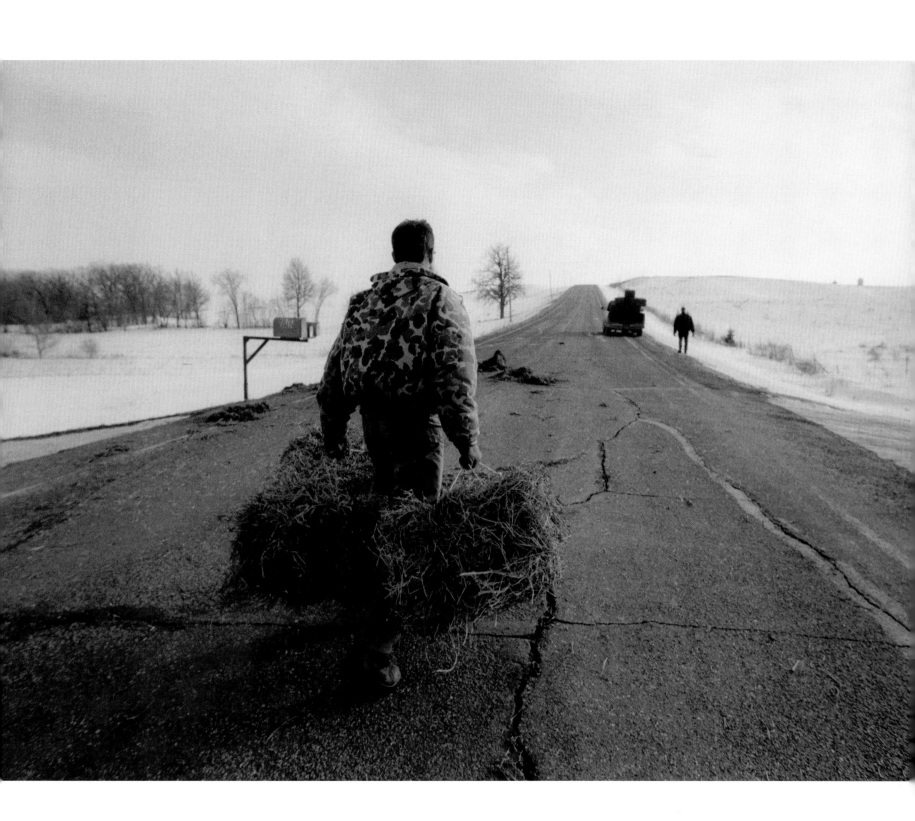

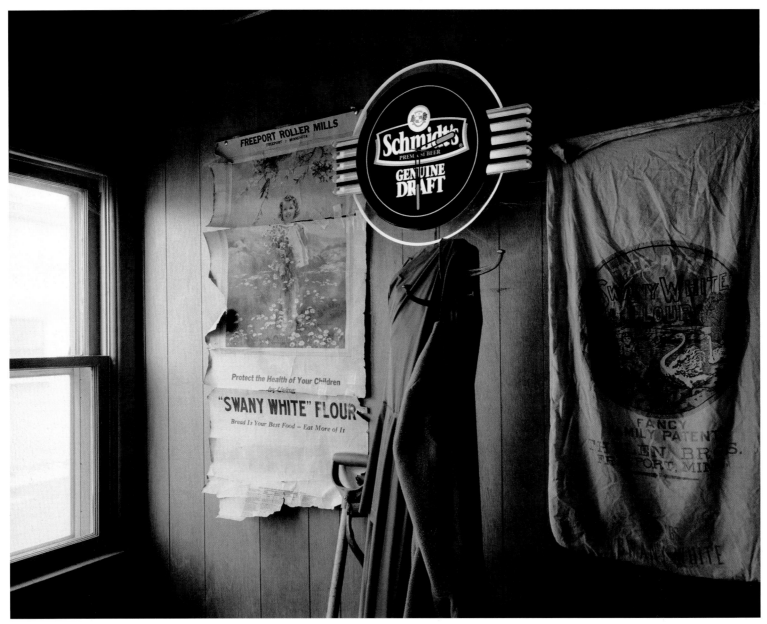

Swany White Flour Mill.

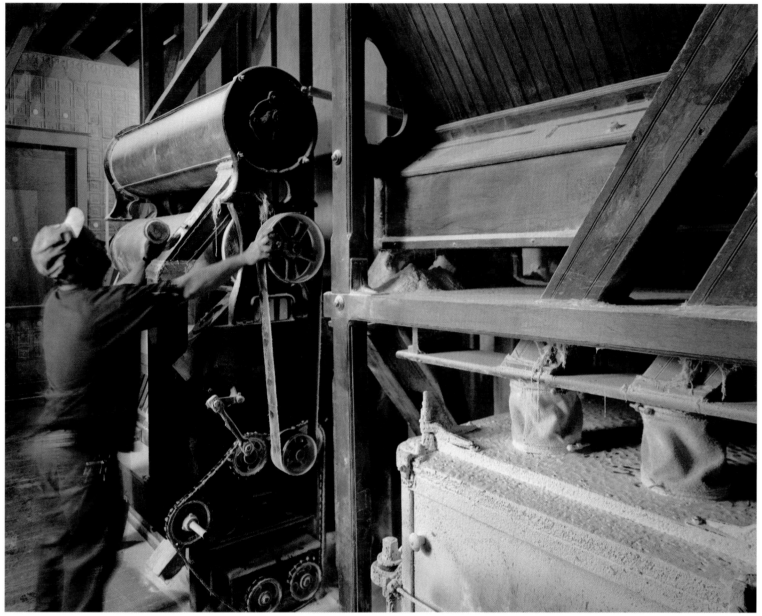

Sifters at Swany White Flour Mill.

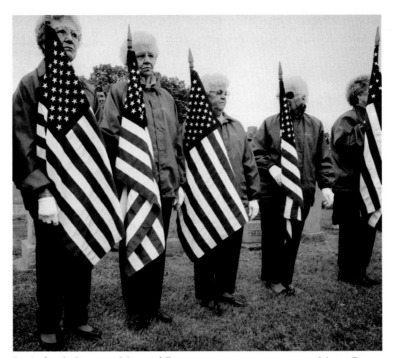

St. Andrew's Cemetery, Memorial Day. MEIRE GROVE

The Catholic War Veterans Post #1685 gathers at Luethmers Bar in St. Wendel on Memorial Day. They attended Mass in the morning and then visited five cemeteries to place flags and flowers on the graves of all veterans, say a prayer, fire a three-round salute, winding up at St. Columbkille Cemetery in St. Wendel. They have a beer at Luethmers, and wind up in Opole at Immaculate Conception for lunch. The bar is owned by Jim Luethmers, who bought it from his mother Irene, who inherited it from her husband Al, who acquired it in 1933, when alcohol became legal again. During Prohibition, from 1919 to 1933, homemade whiskey, wine, and beer were common in the county, made by farmers in copper wash boilers. *Nobody considered it wrong,* said one farmer. *All the neighbors were making moonshine for themselves and their friends and relatives. People picked up a gallon whenever they had a party. They sold it out of the basement of the corner store in Freeport.*

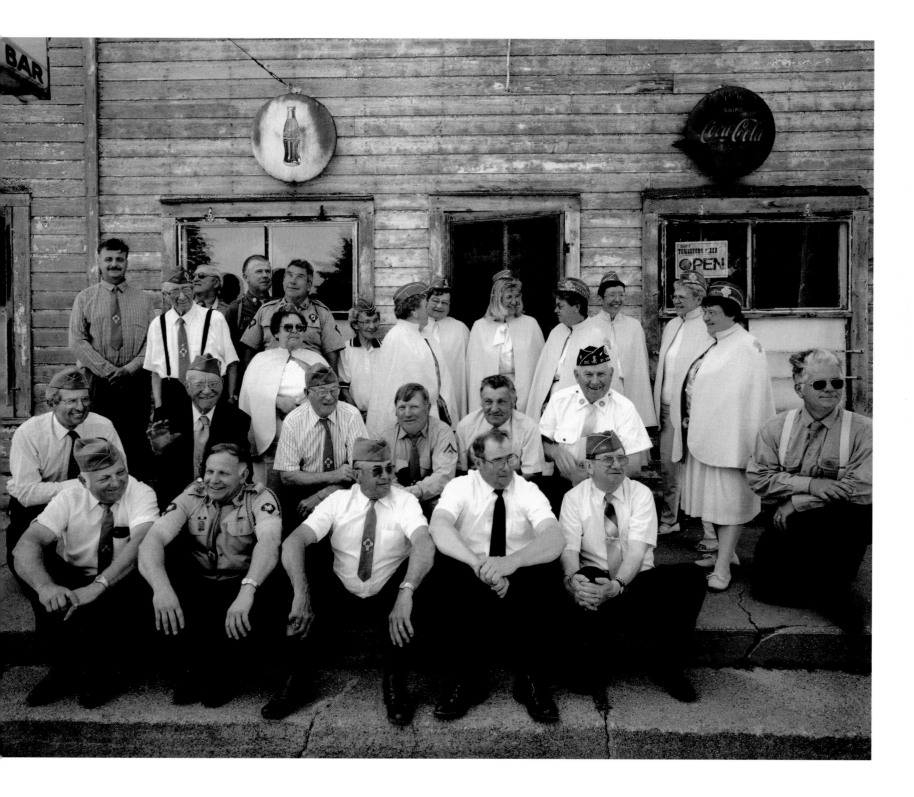

Lent is the forty days between Ash Wednesday and Easter Sunday when you look out at the snow and think about things. It's time to take a close look at yourself and how you are conducting your life and have a truthful moment in the midst of all this damn entertainment. If you really believe what you say you believe, or what you let other people think you believe, why are you so gloomy and troubled? And why do you curse at other drivers? And why are you so oblivious to the needy and suffering? O ye of little faith. Most people do not believe, frankly. They try to and they wish they did and from time to time they like to be around others who believe, so they come to church, and there's nothing wrong with that, but it is good to face reality. This combination of nostalgia and cruel self-righteousness that people consider religious faith—really, one can do better than that, and if you cannot, then you ought to try to be a more interesting sinner.

—THE MEDITATIONS OF FATHER EMIL DWORSHAK

Winterscape. NORTH OF ST. JOSEPH

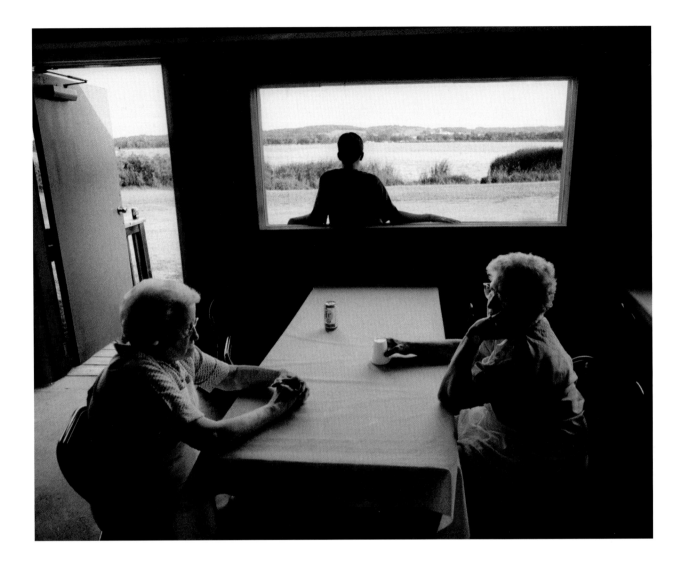

The ladies of the kitchen at the Pelican Lake Ballroom wait for electrical power to be restored so they can resume cooking for Chicken Tuesday. The ballroom is a social center in St. Anna. It was built in 1939 as the Silver Slipper and is owned by the Schmainda family.

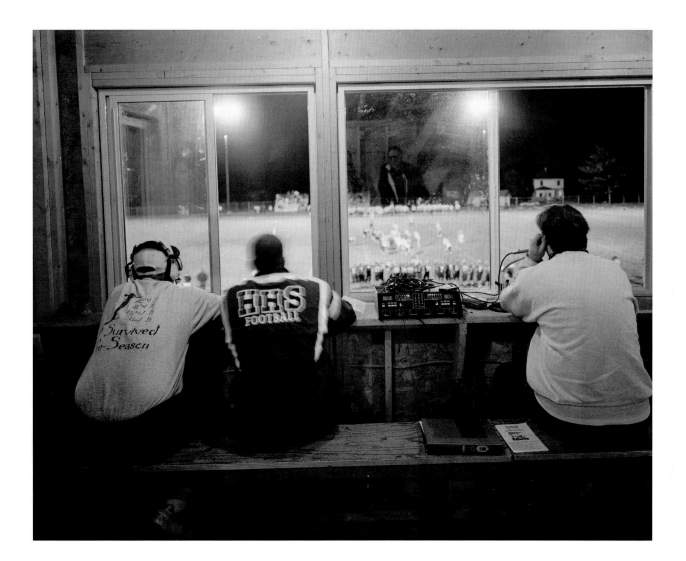

In the press box at the Holdingford football field, two assistants follow the game and report to the coach on the field while an Albany radio announcer does play-by-play for the folks at home.

Aaron Meier, Holdingford: *My parents graduated from Holdingford—my dad was from town, my mom from out in the country—and I grew up in town and graduated there. I'm a senior at Mankato State, and if I could choose, I'd probably choose to come home after I graduate. I like the small town. Mankato is too big for me. If I ever had the chance to come home, I'd come home. To go to the football games and talk to people. And see my brother Gary play. Pretty much anyone you talk to who's from Holdingford, Avon, Albany, what have you, they're proud of where they're from and they love to come home.*

Fishing contest start.
KING LAKE, FREEPORT

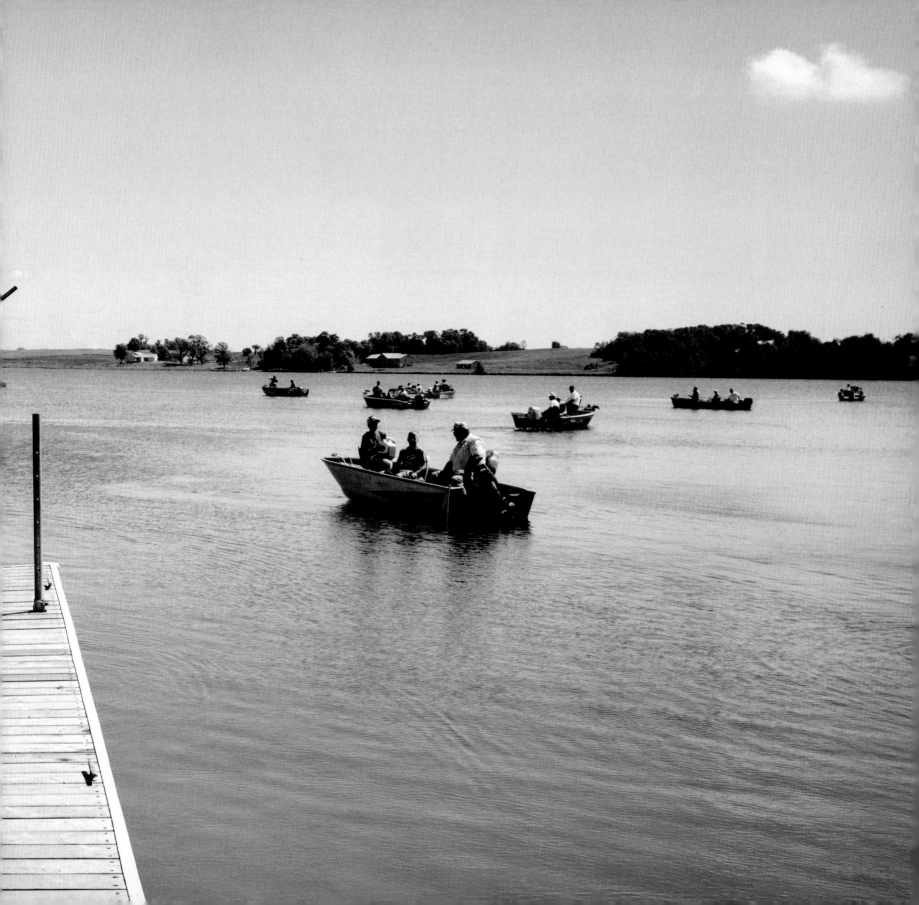

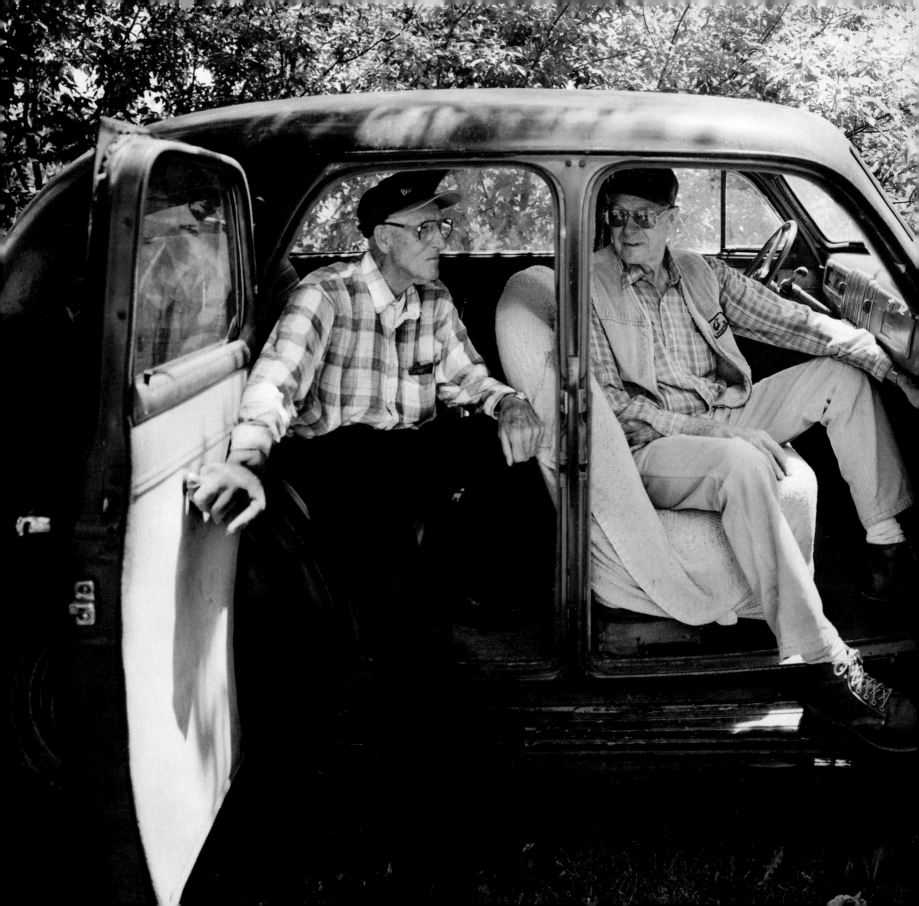

Ed Petermeier with his brother Herman, ninety-three, in the backseat. *I'm going to be eighty-six and I was born on this place. My grandparents farmed west of Meire Grove after they came from Germany. This is where my mother and father originally settled. A hundred twenty acres and only twelve acres was cleared when they started out.* Herman: *Back in 1933 when they closed the banks for two weeks, our dad lost half the money he had in the bank. The bankers wouldn't open up unless you signed a paper saying you'd forget half of it. But the money Dad put in the property, that money was safe.* Ed: *I farmed here, raised pigs and chickens, a few cattle, and was a welder for sixty-five years. People came from all over to get their farm implements fixed. Seven children. The oldest is a missionary in Indonesia. A daughter in Arkansas, a son in Minneapolis, otherwise they're close around here. It was a good life, better than it is now with the big farming. I made a living. Plowing with horses, that was so nice and quiet. I'm awful against this spraying. You can't tell me that that don't go up in the food. You and I are eating the chemicals. We used to plant clover and plow it under and that was the best fertilizer you could have.* Herman's son Donny: *Dad and Ed are both active and they never lose interest in life. I think that's how you get to be that old.*

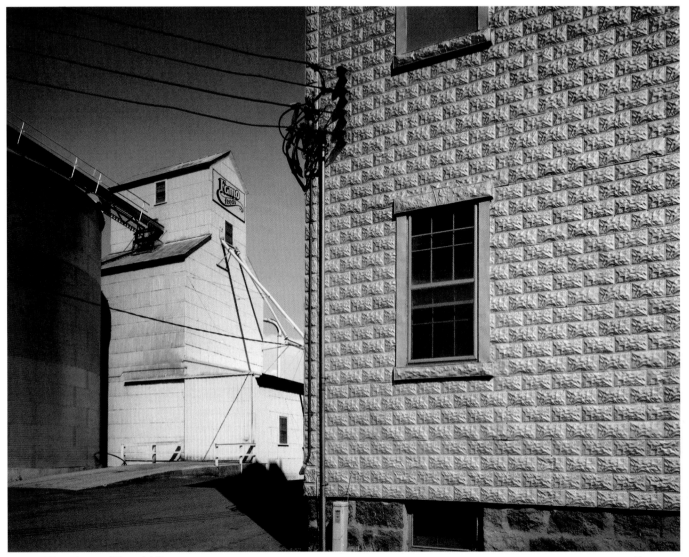

Swany White Flour and Famo Mills.

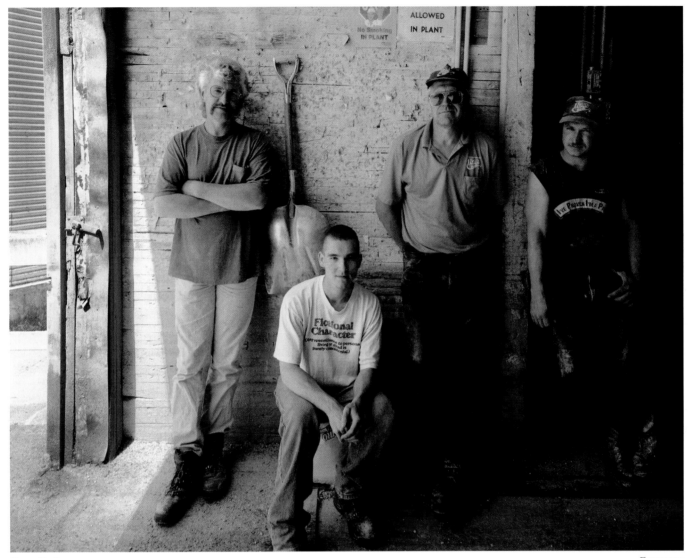

Famo Feeds.

Aformer worker at the feed mill: *I quit at the feed mill. I got smart. It's shit work, is what it is. You make feed, corn or whatever, crack it and mix it up with oats, protein, soybean meal, and stuff like that. And send it back to the farm. Some in bags and some in bulk. They tell us what they want and we mix it up. But it doesn't pay, so I got the hell out. But don't quote me by name.*

Quarry.
COLD SPRING

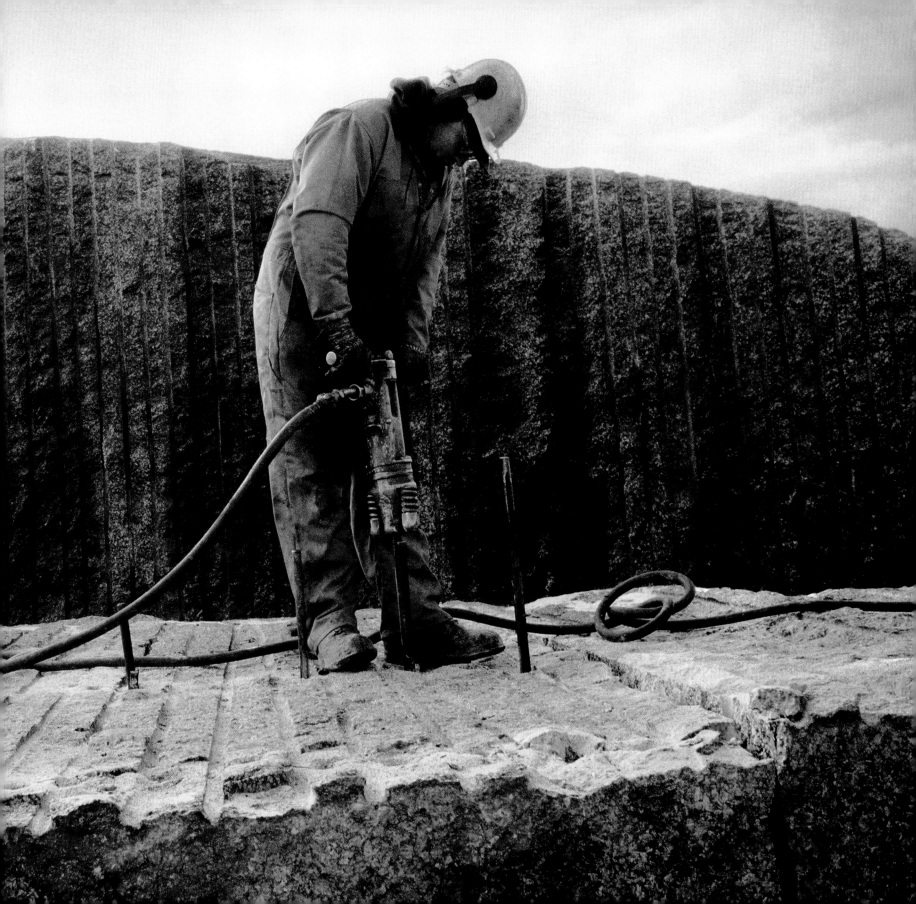

F armers are a natural aristocracy of competence, men who from one day to the next may need to be carpenter, mechanic, butcher, veterinarian, electrician, welder, or plumber. You can't farm if you don't know what you're doing. A farmer deals with many little disasters without calling 911 or AAA. He understands hydraulics and gasoline engines and electric motors, can grease a combine, fix a corn planter, check compression, pour concrete, build a pole barn, deliver a calf, gut a deer. And farmers' wives are right beside them, women who never read women's magazines because who wants to hear that you're homely and don't have good enough sex, so they don't use hairspray, they just put on a scarf and go out and get on the tractor. But their kids are sensitive about being farm kids and the butt of satire. Farmboys want to be cool, too, and they know that cool girls don't want to be stuck on a farm, so the boys go to college and major in communications and learn how to talk through their hats. They worry about looking good and saying the right thing and they marry beautiful women in search of themselves and they have sons and their sons are unable to change their own oil or replace a toilet handle. But they are sensitive and thoughtful and they earn buckets of money, though they couldn't pour piss out of a boot if the instructions were printed on the sole. You figure it out.

—THE NOTEBOOKS OF CARL KREBSBACH

Heading to night pasture. ST. ROSA

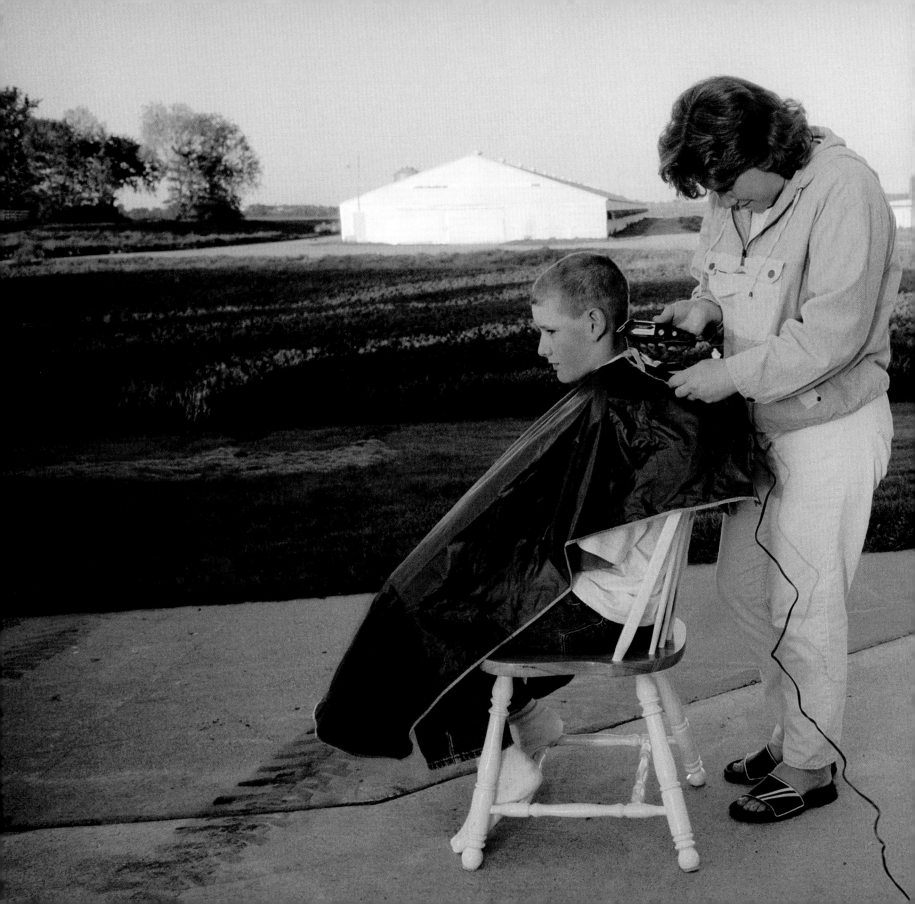

Boys in the high school yearbook look like movie stars now and have movie hair and ride to the Prom in a limo, decked out in stylish tuxedos of aubergine, or burgundy, or cobalt, or delphinium, ecru, fauve, geranium, heliotrope, indigo, jonquil, kumquat, lapis lazuli, mauve, nutmeg, ocher, plum, quail, raven, spearmint, turquoise, ultramarine, violet, wisteria, Xanadu yellow, yeast, or zinc, but back then it was all shiny black tuxedos, slightly too big, and every boy's hair looked like he was just getting over a bad case of head lice. Every month, whether you needed it or not, your mom got out the electric clippers and scissors and comb and white sheet and you submitted to a home haircut though your hair had not quite recovered from the last one and as she pinned the sheet around your neck, you told her, "Not too short on the sides," and she clicked on the clippers and ran it up the back of your skull, cold metal to skin, hitting a few snags on the way, and there went your dream of you at the wheel of the white Caddie convertible, your golden locks blowing in the breeze—no, your hair isn't going to blow anytime soon, because Too Short is the only hair style available around here. We are not going to throw away good money on barbers, not in this house. She finishes shearing you and looks over her work and snaps off the clippers. It's good enough. Don't complain or she'll give you something worth complaining about.

— 99 Theses 99

Lois Harren cutting hair. Freeport

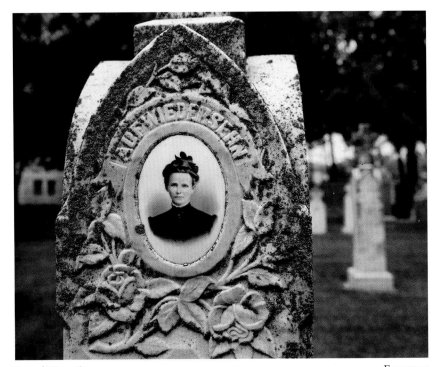

Sacred Heart Cemetery.

Here lies Carolina Hoeschen, born Carolina Bockholdt in New Munich in 1872. Married Moritz Hoeschen, a Freeport storekeeper, and bore six children, two of whom died in childhood, and died herself in 1908, and now resides in Sacred Heart Cemetery in Freeport, among Klassens, Hemkers, Heidgenkens. Old stones with German inscriptions (*Hier Ruht in Gott*). At her feet is a row of ash and chokecherry trees and a group of headstones with little lambs lying atop, the graves of small children who died at the turn of the century. Arnold Hoeschen of Freeport, a relative, says that Moritz built the Swany White Flour Mill: *Hoeschens are the dominant family in Freeport, I guess you'd say. If you're not a Hoeschen, you're probably married to one.*

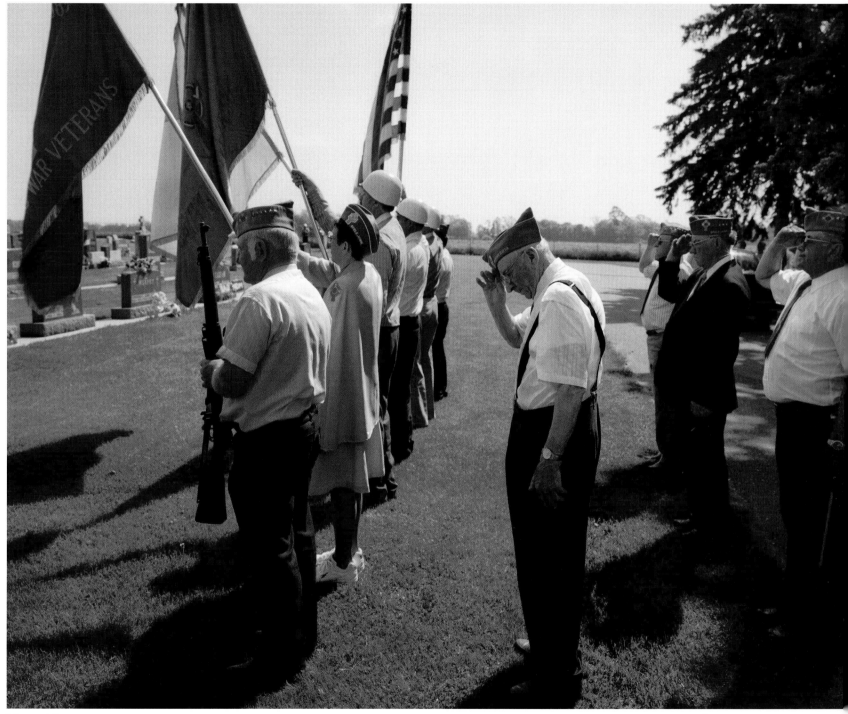

Memorial Day.

Ervin: My family's been here one hundred years as of last year. Millwood Township, seven miles northeast of Melrose. My grandfather Bernard Kerfeld was born in Hanover, Germany. He came over with his parents, Heinrich and Agnes, when he was ten years old. They were poor people, with no land, working six days a week for their landlord, and they stayed up half the night weaving rag rugs to make money for the trip to America. They landed in New York and had no money and somehow got word to a brother-in-law up by Long Lake and he forwarded them money to come to Minnesota. Grandpa bought 160 acres from a home-steader. He was hard-working like all Germans. He built the house we live in. Around 1915. He had seven kids, including my dad, Leo, who had seven, and my wife Jeannette and I, we have nine. Eight boys and a girl. And my son Randy is taking over for me this year. It's 430 acres now, 260 cultivated, corn and oats and alfalfa, and we raise feeder pigs and dairy. We're milking fifty Brown Swiss. My dad had those and my granddad before him. During the hard times in the thirties, Dad and a couple neighbors took their cattle on the train north to Bemidji to graze in the woods because there was nothing green around here. Dad got high blood pressure and he left the farm on a doctor's advice. He moved to Sauk Centre. He loved to play cards at John's Place, a little beer joint. Every morning, he'd walk a mile into town to church and then play cards and come home for dinner and walk back in to play more cards in the afternoon. He lived thirty more years after he retired. All that walking was good for his heart.

The Ervin Kerfeld house.

NEAR ST. ROSA

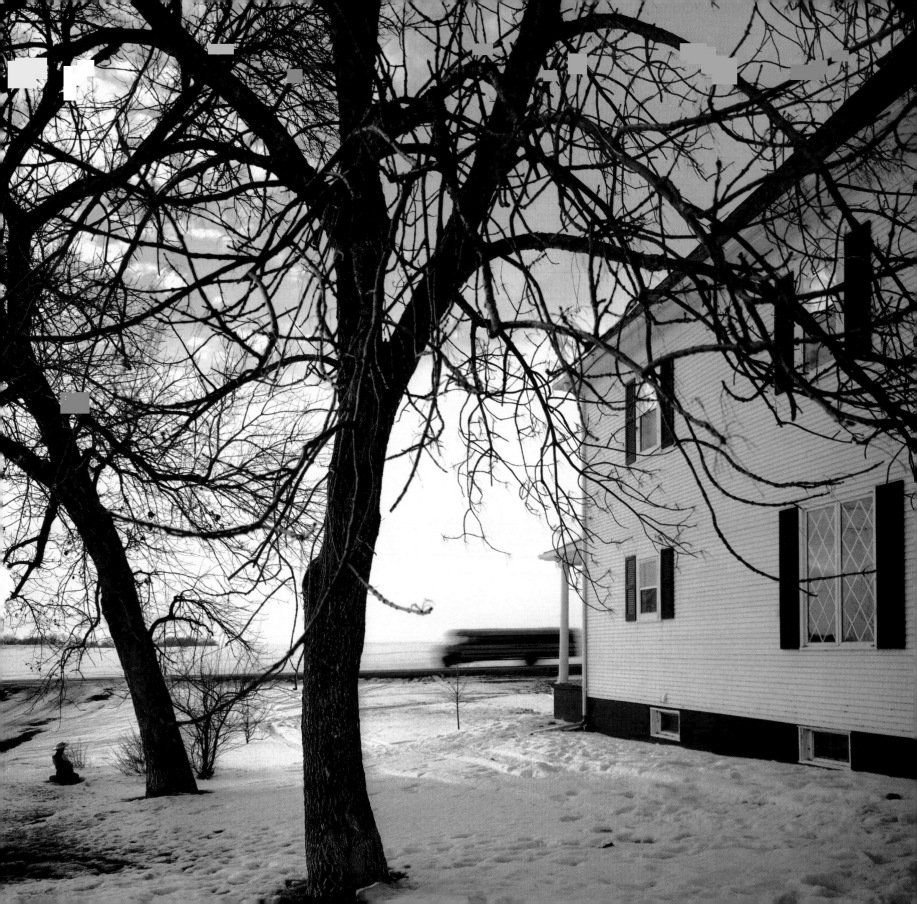

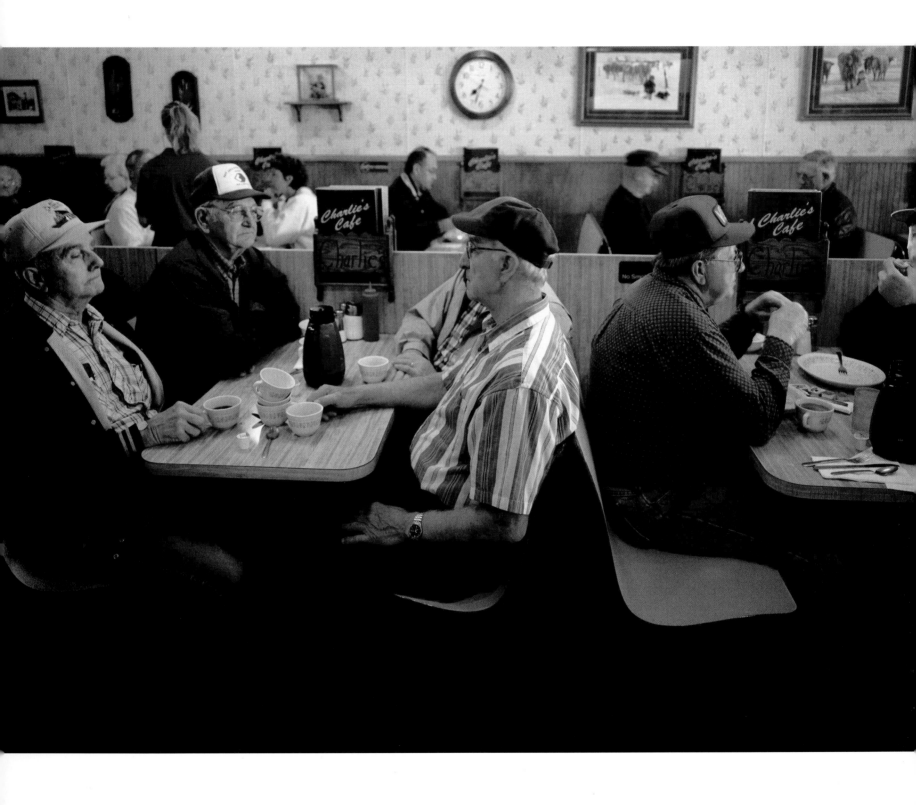

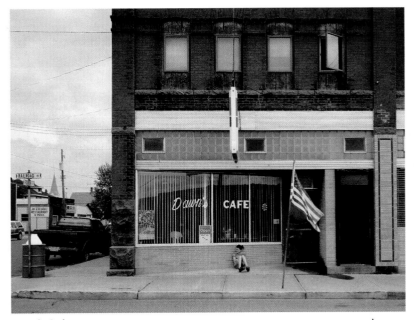

Dawn's Cafe.

In Charlie's Cafe on Main Street in Freeport at 7:30 A.M. the regulars come in for coffee. From left, they are Gilbert Roerick, Max Wenker beside him, Tony Funk (hidden, across from Max), and Art Van Heel (in the striped shirt). In the booth to the right, Butch Bonfig and Larry Beuning. Mr. Van Heel: *Most of our gang goes in about seven in the morning and sits around for an hour or so, having coffee. We've been going in there for years and years, and we sit at the same booth unless somebody beats us to it. Coffee just went up to 90 cents, from 75, but in St. Cloud, it's $1.25, so you can't complain too much. We shoot the breeze, catch up on the gossip. We talk about politics some but if it gets too rough, we drop it.* Mrs. Larry Beuning: *The men always sit in the front and the women in back. When he has a day off, he likes to go in and have coffee and see who knows what. Usually the retired sit together and the fishermen sit together. It just seems to happen that way. They talk about how fishing has been and then run home and get their poles and go fishing.*

Tuesday softball.

Richard Roerick family.

A farm on the Sauk River in winter. The Superior glacier came through here about six million years ago, leaving sandy soil, which, had the Moorhead glacier moved in faster from the west and beaten the Superior glacier to the spot, would have been richer soil and the farmers would have been richer, too, but it didn't, and they aren't.

Overleaf

Frozen farm pond in winter.
NEAR ST. ROSA

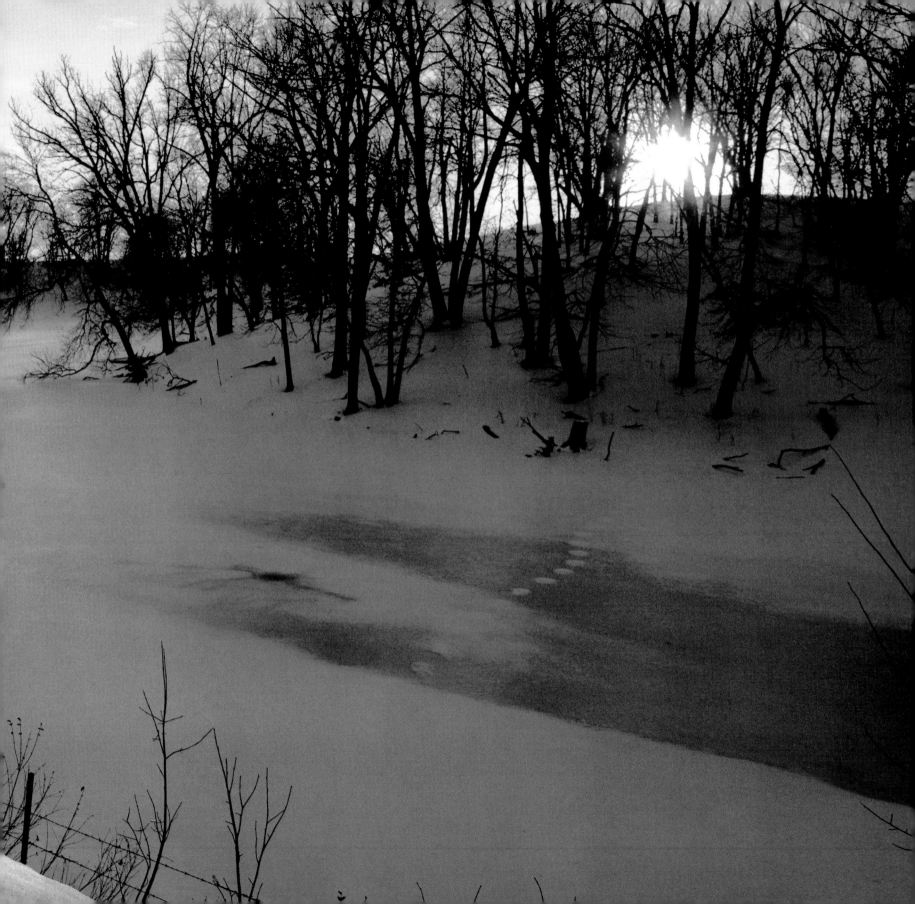

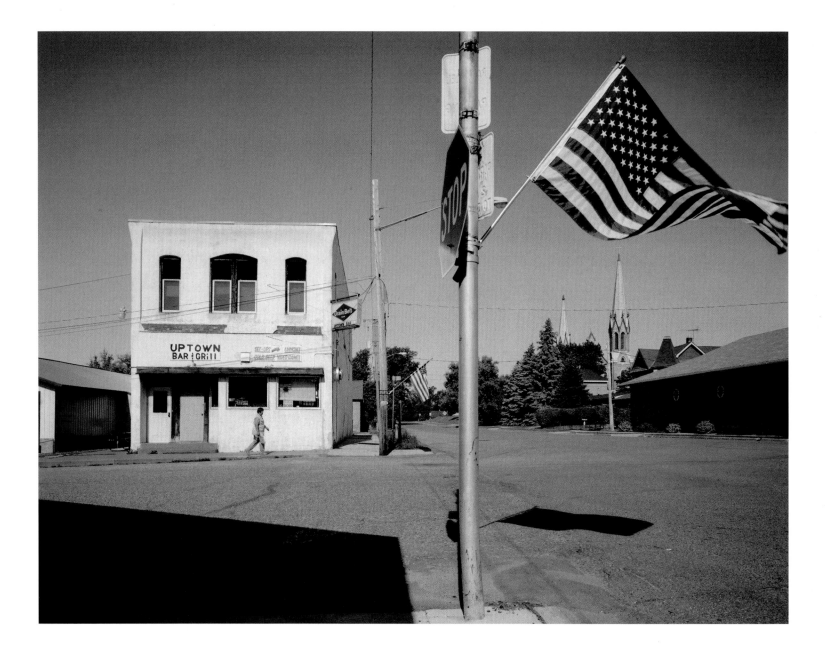

The Uptown Bar & Grill at 5th and Elm in Waverly. Formerly the municipal liquor store, and before that, a store operated by one Joseph Kevetensky, who emigrated from Bohemia in 1882 and by 1902 owned a block of businesses including this one.

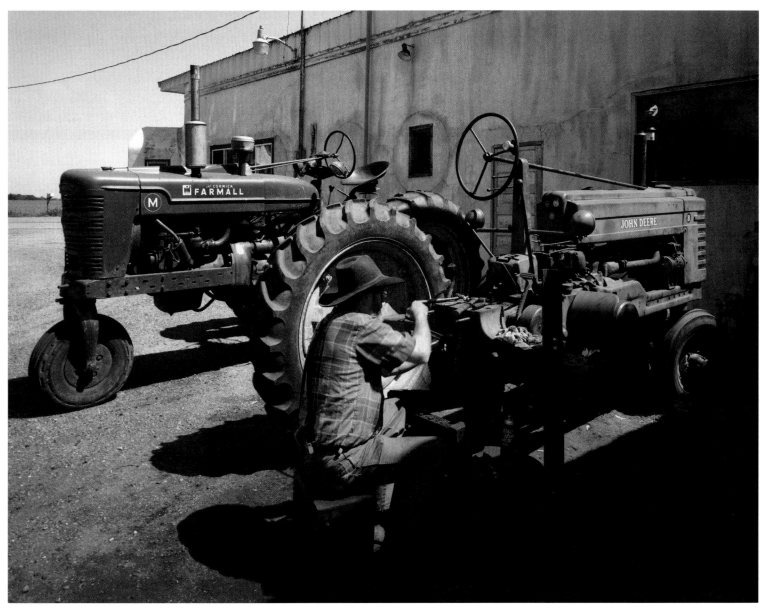

John Achmann's tractor repair.

It was Toast and Jelly Days last weekend, and we had good weather for it. They held the toast toss, won by Ronnie P. (166 feet), and the grocery run, and a casino in the fire department with blackjack and rap poker, and the Dunk the Pastor booth was very popular. Father Wilmer and Pastor Ingqvist took turns sitting on the little perch above the water tank. Clarence kept explaining to people that you don't have to throw hard, just hit the steel target that pops the hinge and drops the victim in the drink, but people were winging fast balls, old ladies stepped up and took big windups, people with fistfuls of dollar bills. The Lutherans put on a Jell-O contest in the Lutheran Church parking lot, and there were a number of creative entrants. A grayish Jell-O in the shape of a human brain, for example. Somebody put a lot of thought into that, and also the Jell-O map of Minnesota, but first place went to the Last Supper done entirely in Jell-O, Our Lord and His apostles in lime green outfits, with strawberry faces, sitting at a coffee-colored table. You could not *not* give the blue ribbon to the Last Supper, although the brain was a fine piece of work.

—THE NOTEBOOKS OF CARL KREBSBACH

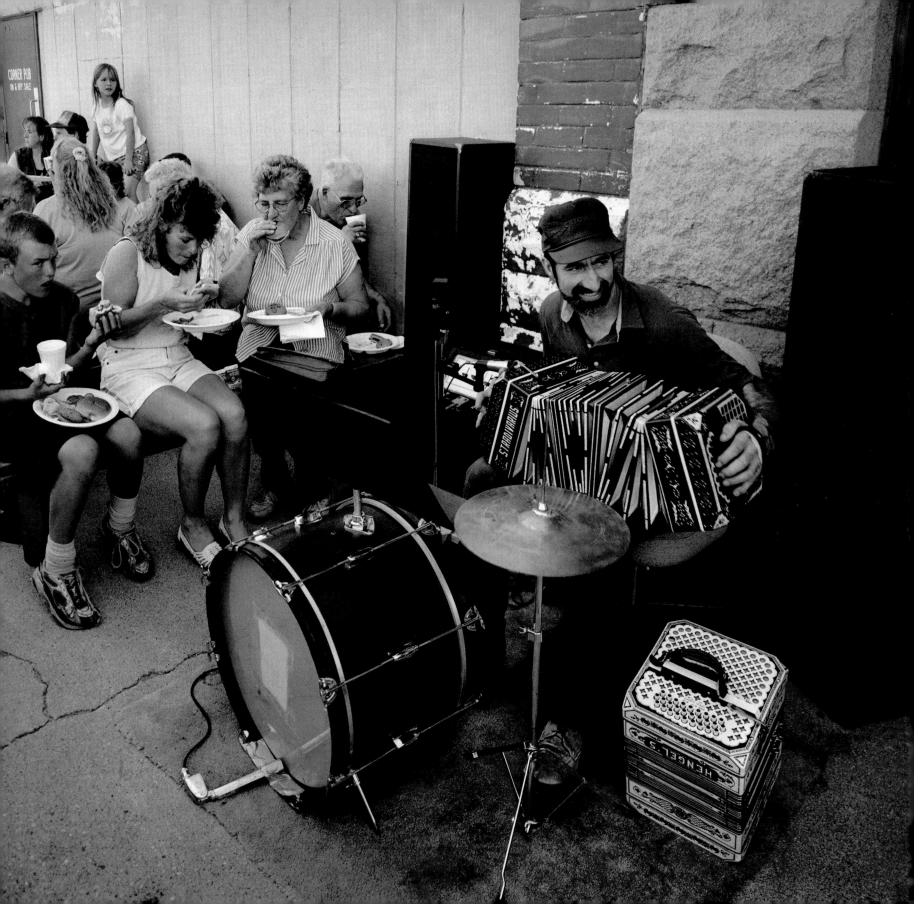

Holstein ___ *to pasture.*
ST. WENDEL TOWNSHIP

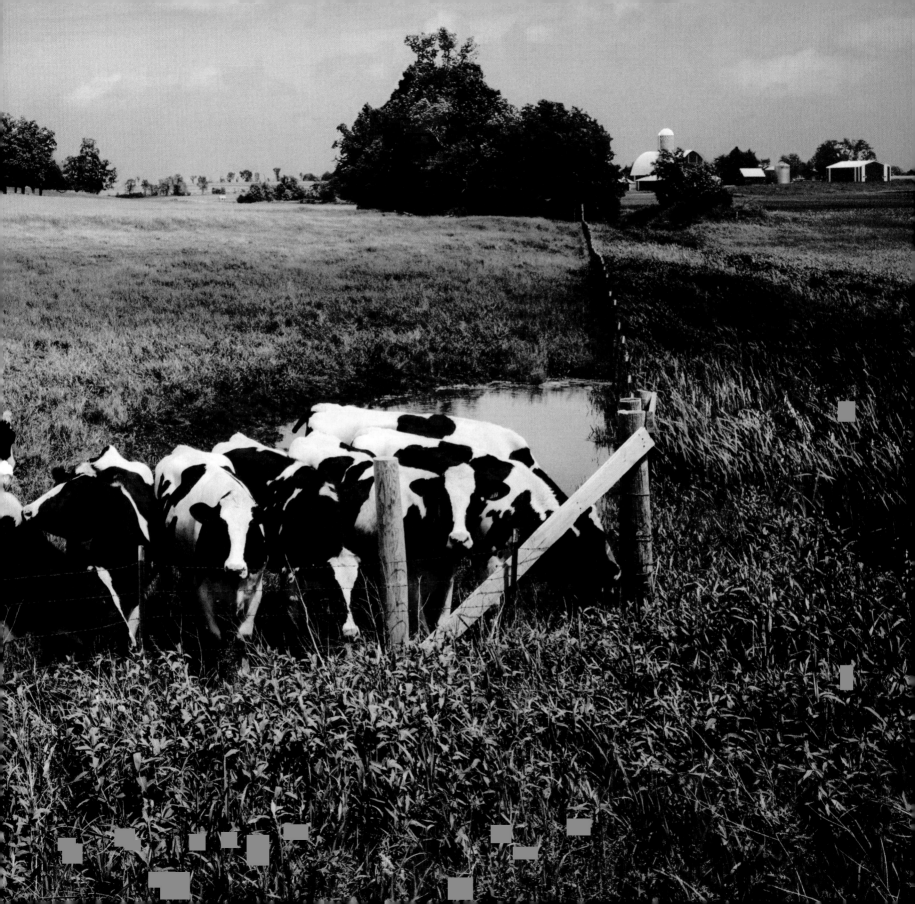

Arthur Hoeschen (LEFT): *That's me cleaning sunnies with my fishing buddy Lumpy. Linus Bonfig is his name. We like to take a boat out on Sauk Lake up by Sauk Centre or over to Minnewaska. Up north they want a sporting-type fish but we prefer sunnies. Our limit is what we can eat. When I was working at the bank, every Thursday we'd quit work at three and go fishing and catch enough to have a fish fry. We'd clean the fish and play some cards, have a few bumps, and when we started getting a little loud, we'd fry the fish and that was the end of our day. It was fun.*

Cleaning fish. FREEPORT

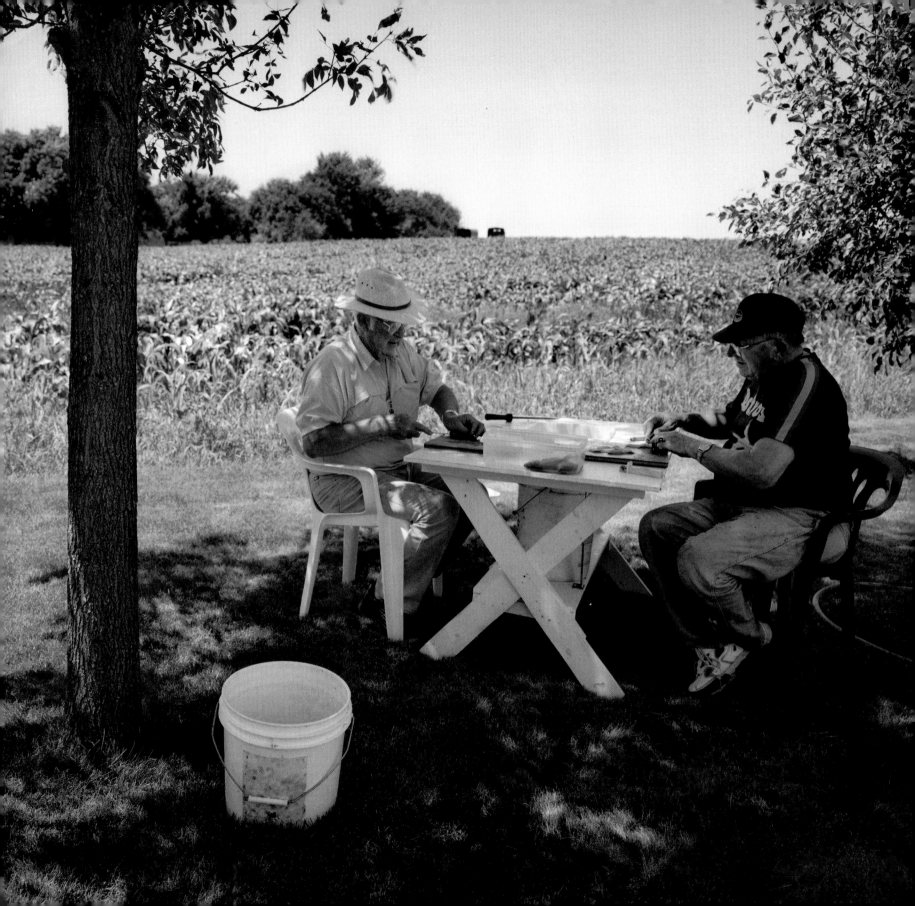

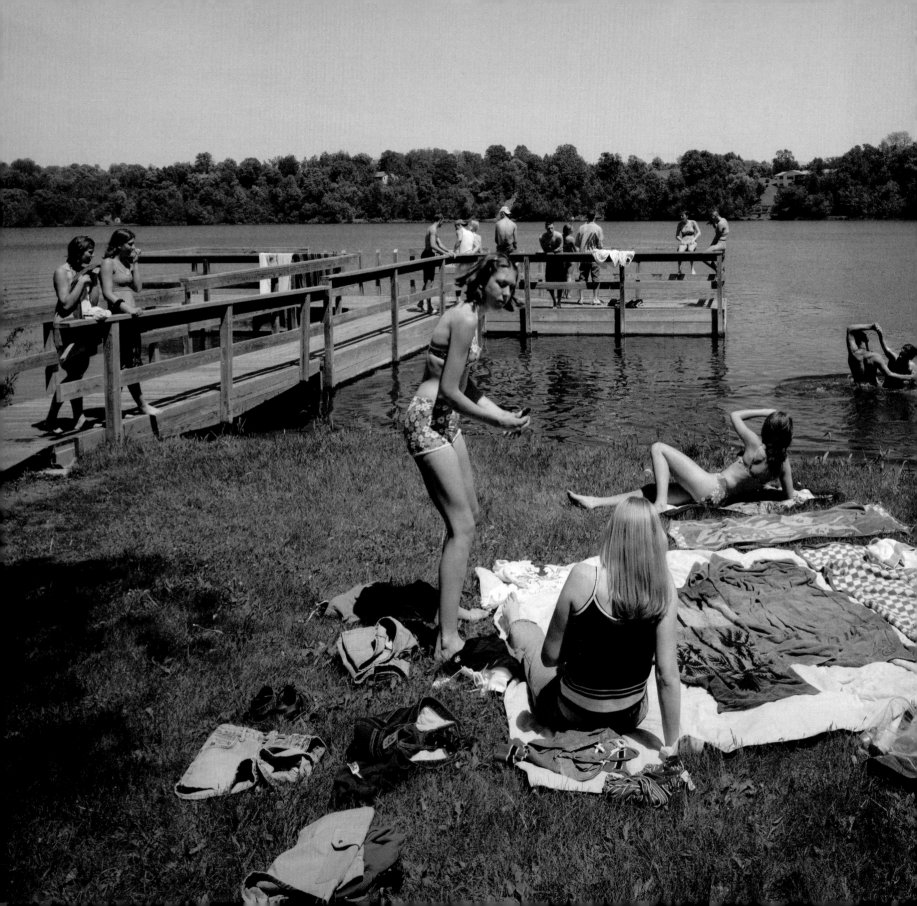

eenagers from Melrose hang out at Lake Sylvia. The girl at the far left is Brianna Hill, seventeen: *The same crowd comes here just about every day, ten or fifteen people. Midafternoon, right around two or so. I usually go with Briana Zenzen and Sheena Hoeschen. We're all pretty outgoing. The main hangout at night is the Conoco gas station in Melrose. We hang out and talk and figure out where the local party is. Parties go on till about one. It's cool if you're alone, and girls talk to boys whether they have a boyfriend or not. It's cool.*

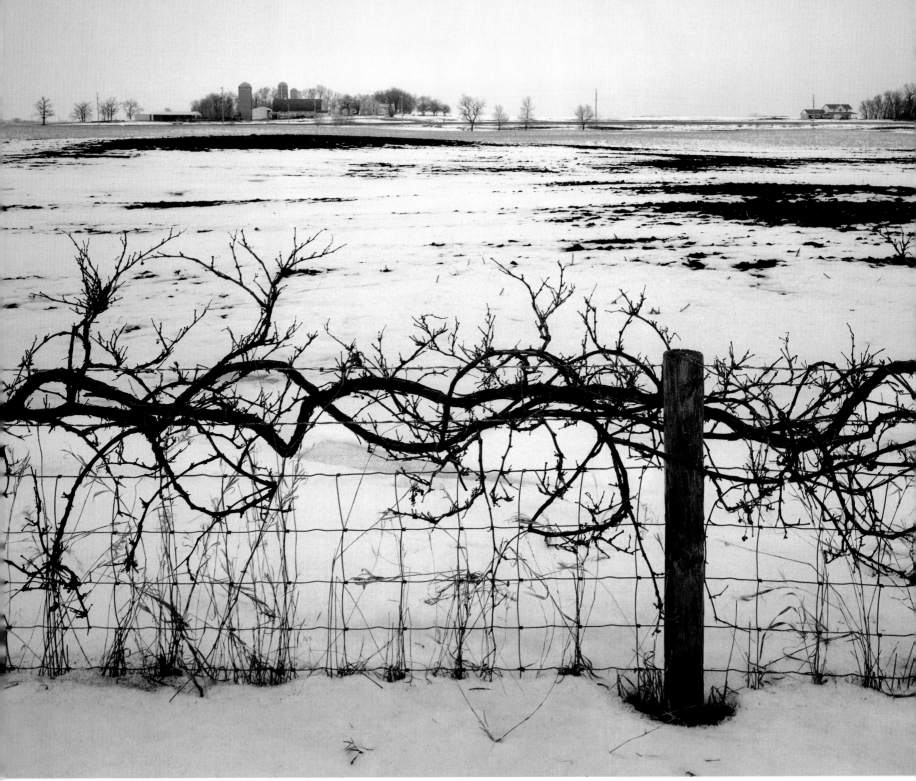

Winter landscape.

NEAR FREEPORT

84

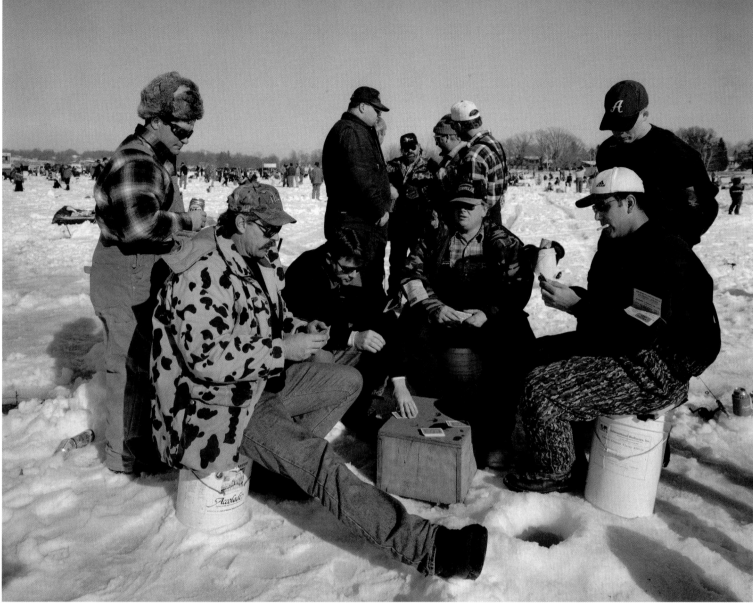

Men playing cards during the St. Joseph Rod & Gun Club annual ice fishing contest.

Lake Kramer

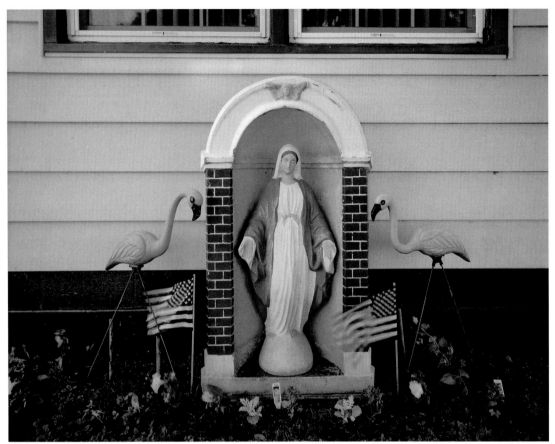

Grotto with B.V.M.

Leo Thyen gardening, with his dog Dino, at the old family place in Farming, despite Parkinson's slowing him down. *This was my home since I was six. My mother had flowers here, crocus and tulips, peonies, daylilies, the dirt is so good. She was born in St. Martin, a few miles from here. She worked hard. She raised vegetables, berries. Rhubarb, asparagus, horseradish. She kept apricot trees, chokecherry, grapes, and plums. When I went to school, it had two rooms. In the wintertime, we'd catch a ride down to the creamery on the runners of a horse-drawn sled. We used to skim off the cream and put it with honey syrup on bread. We didn't talk about cholesterol then.*

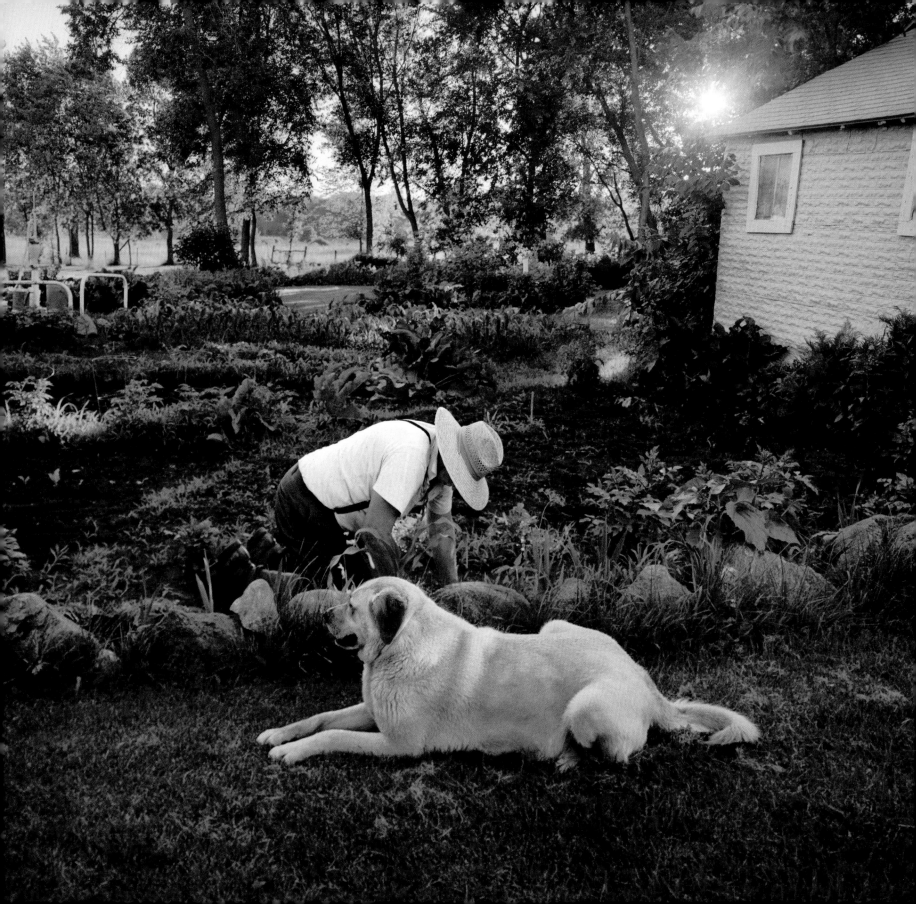

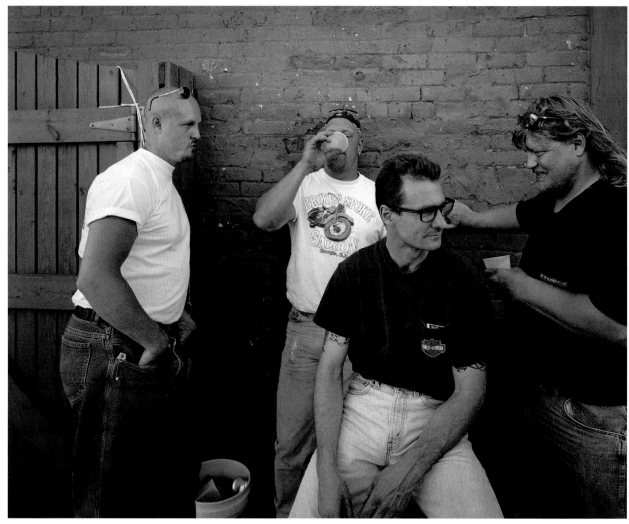

Harley Davidson riders, Memorial Day weekend.

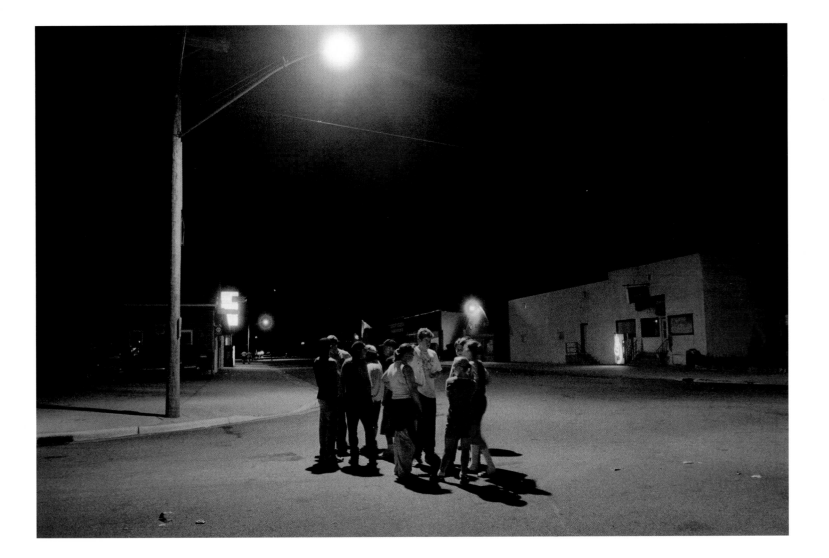

A gaggle of teenagers stands in the intersection of First Avenue South and Main Street in Bowlus around 11 P.M. on a summer night. There's not much to do. The building across the street is Bowlus Liquor, closed, an illuminated Coke machine by the door. The lighted sign ahead on the left is for the gas station, where the pump is open (if you have a credit card). The coffee shop, supermarket, post office, bank, American Legion club are all closed. If you prefer Pepsi or Mountain Dew to Coke, there's another soda pop machine up the street.

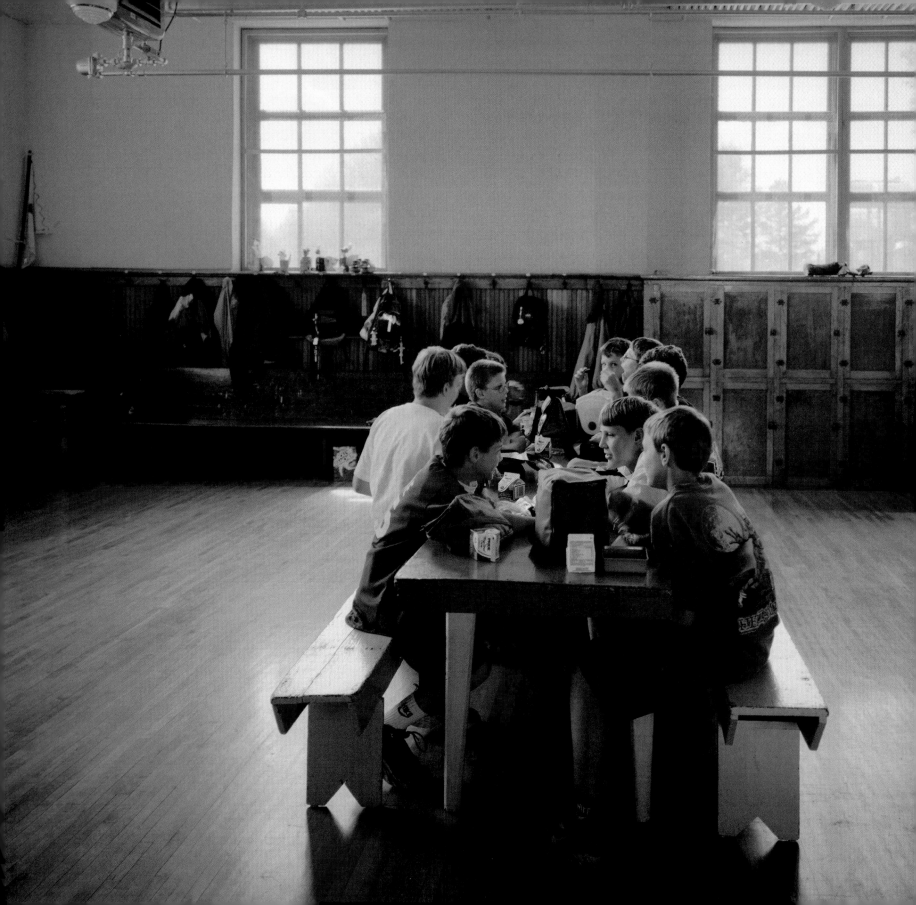

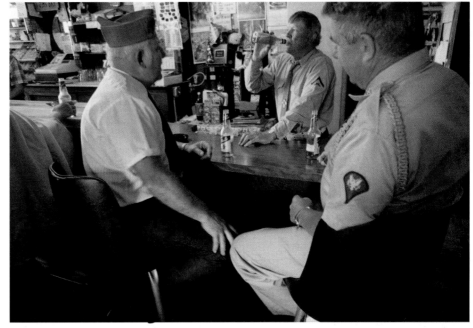

Luethmers Bar. ST. WENDEL

Noontime at St. John's School (grades 3 to 6, seventy students, from forty families) in Meire Grove, and the boys linger over lunch in the activity room with its oak wainscot and maple floor dating back to 1915. Half of the room is given over to basketball. A hand-lettered sign outside says, PLEASE NO VANDALISM. Sister Suzanne Slonimski is the principal: *The school used to be run by nuns and the convent was attached. Folks here were committed to their faith and still are. We have twenty iMac computers, nineteen of them donated. Isn't that incredible? The favorite programs are accelerated reading and accelerated math. The sixth graders just did their autobiographies and scanned in the pictures and they're going to give it to their parents as a gift. And at the end they have to write a thank-you letter to their parents, for giving them life and a Catholic education and all the good things they have in life. These are good, well-behaved kids. They come from good homes so they come to school to learn. They're looking forward to college and a lot of things. They want to be scientists. A couple want to be mathematicians. Some want to be teachers, which pleases me a lot.*

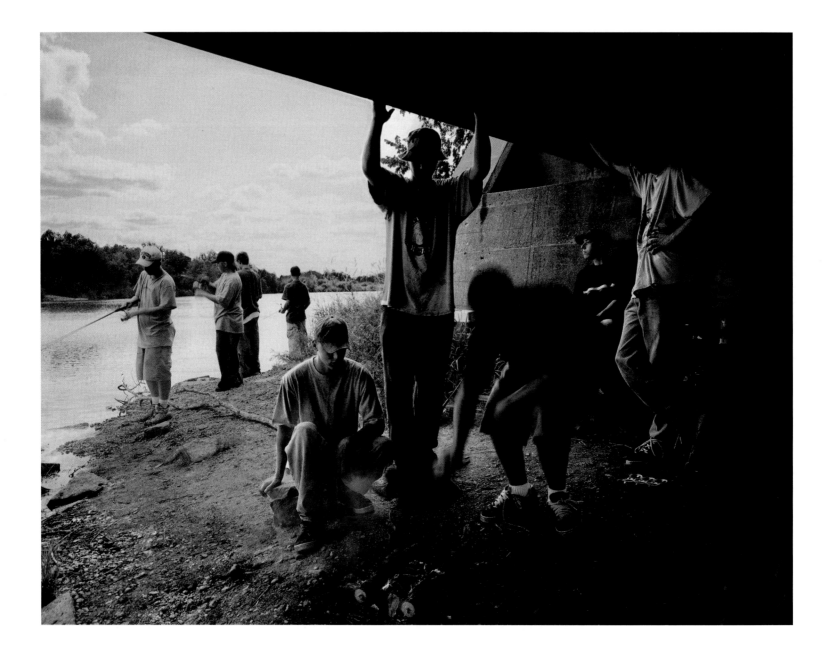

Boys fishing in Schwinghammer Lake, under an old Great Northern Railroad bridge near Albany. The old Breckenridge Winter Trail, a branch of the Red River Trail, came through here, over which French Indians transported furs and supplies between the Mississippi landing at St. Paul and Pemberton, North Dakota. Then came James J. Hill's railroad, and then Interstate 94, and now the old rail bed has been turned into a bicycle trail.

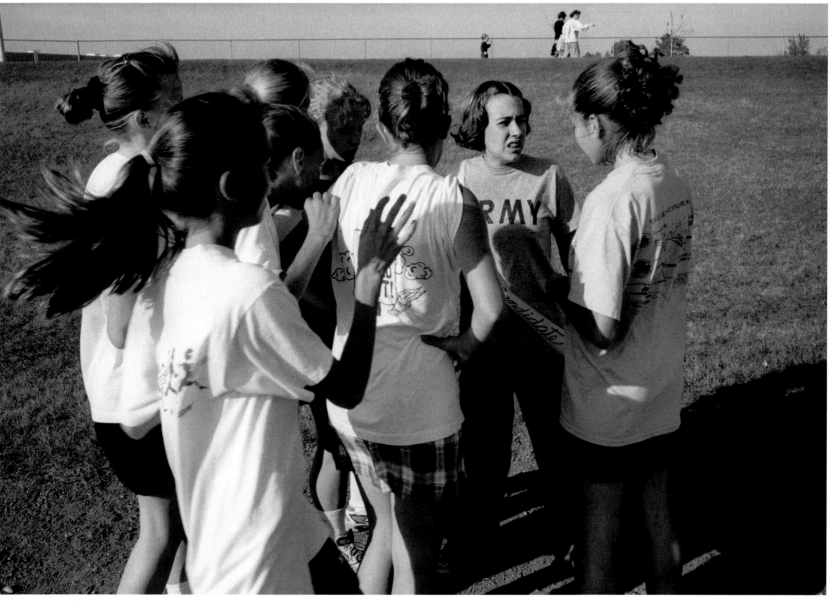

Homecoming practice.

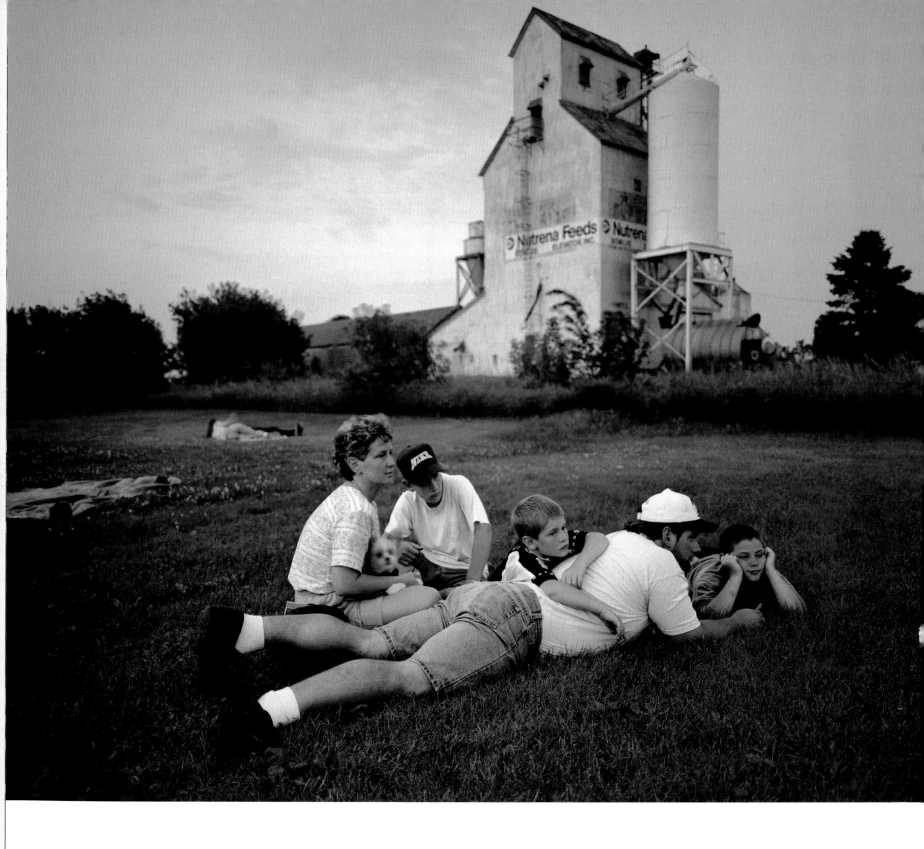

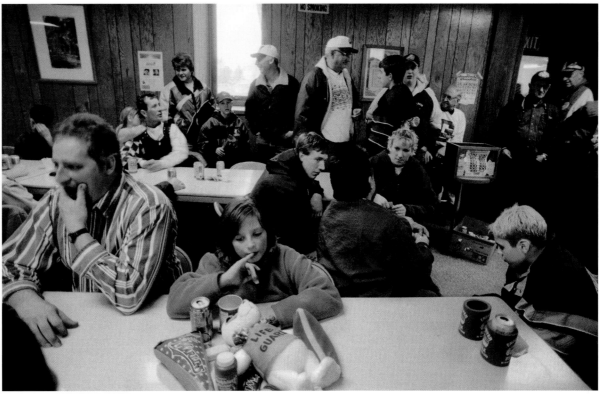

Snowmobile fund-raiser at St. Rosa Catholic Church.

The Segler family—Bob and Joann and their sons Danny, Justin, and Robbie, and dog Misty—waits for the volunteer fire department to start setting off fireworks at Bowlus Fun Day.

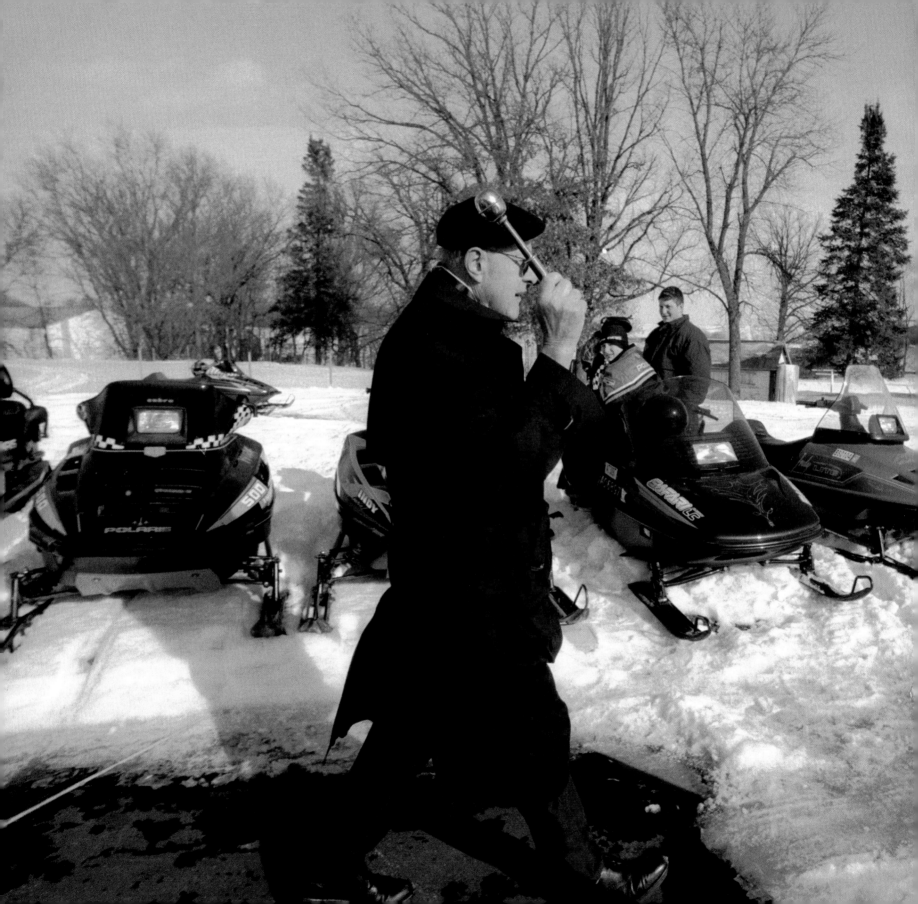

Father Sylvester Kleinschmidt, at the annual Blessing of the Snowmobiles at St. Rose of Lima Church in St. Rosa, standing in for Father Hoppe: *Father Vincent Yzermann started it when he was pastor, back in 1969. He was quite a sportsman and liked to ride snowmobiles. He composed a special prayer, but I do my own, just thanking God for the ingenuity of the people who invented the machine and asking His protection of the riders. It's the first Sunday in February. They changed it once but that's when it usually is. It's organized by the Roving Hillbillies Snowmobile Club, not the church, and it's a fund-raiser for them.*

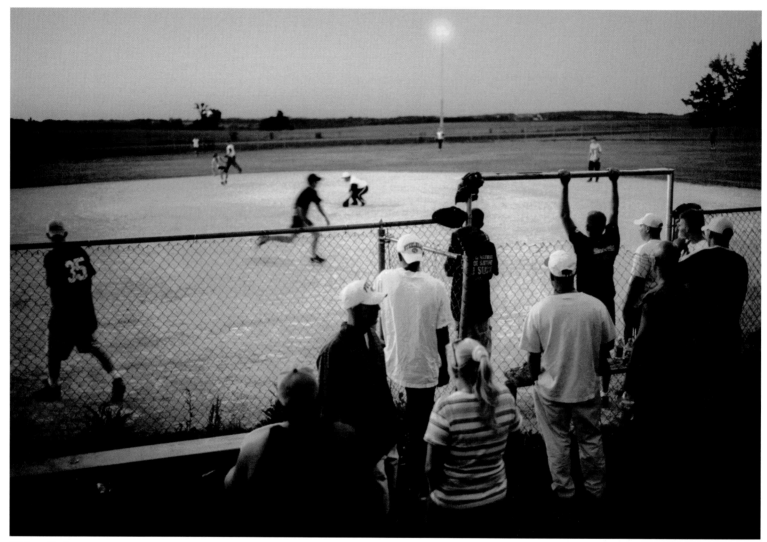

Night softball.

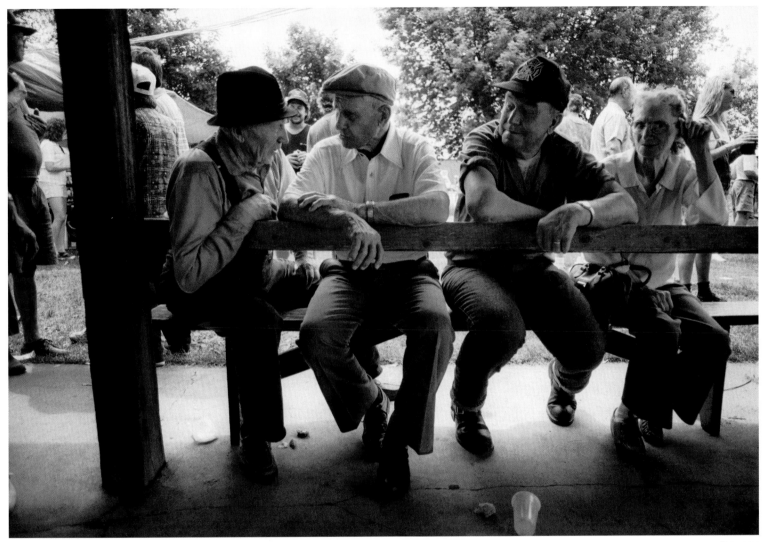

At the polka band concert.

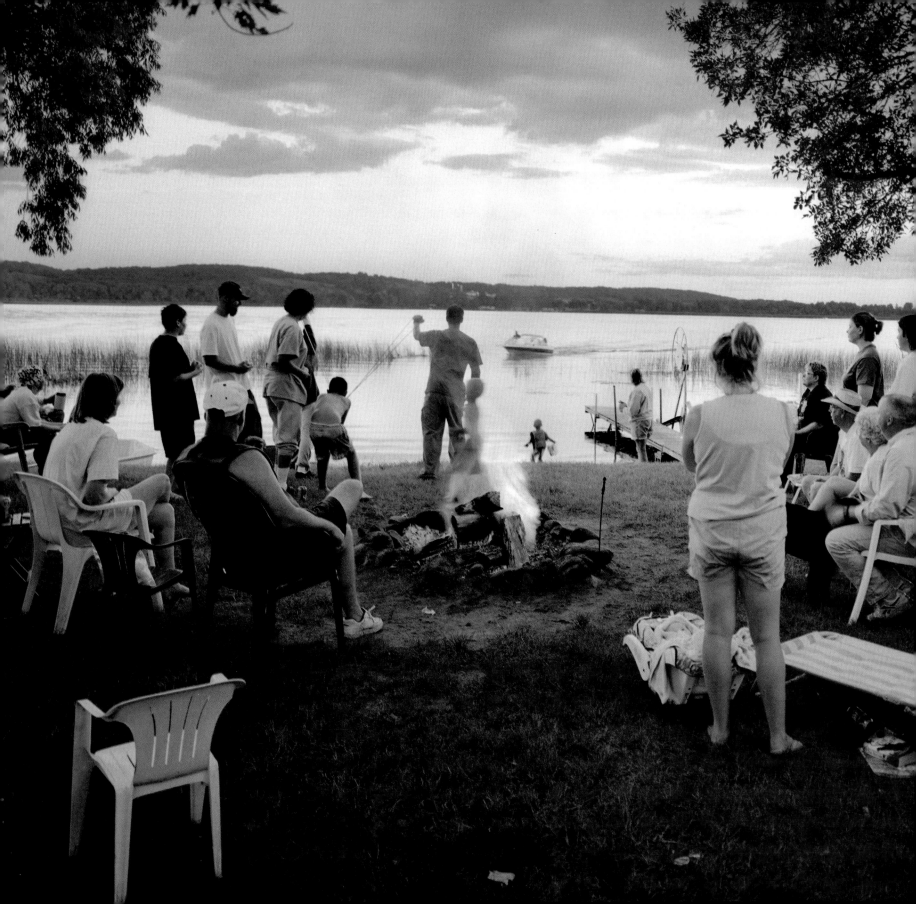

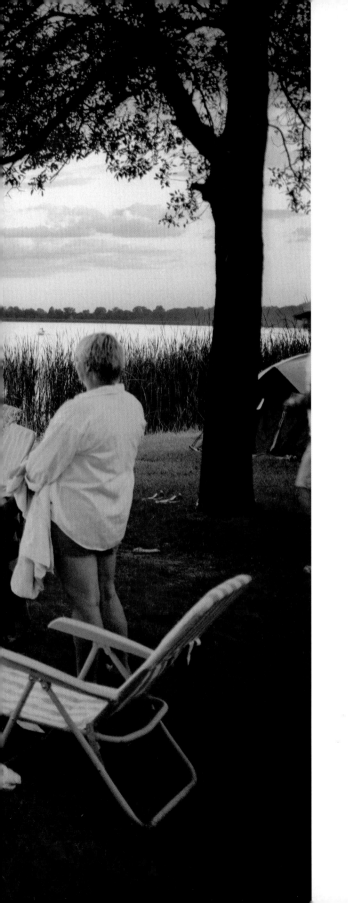

The Lund family at its seventh annual get-together at Gary and Lynda Lund's cabin on Pelican Lake near St. Anna. More than forty Lunds come every year and camp out and catch up on the news, including Hazel and Bob and Mom and Dad Lund. Everyone is watching a young Lund on shore as he takes aim with a water balloon at the boat that a brother-in-law is navigating toward shore.

G ary Thelen leaning against the bran finisher in the Swany White Flour Mill, Freeport, which has been in the Thelen family since 1903. To the left is the round bin for finished flour. *The bran is the shell of a wheat kernel and we take that off before we mill the rest into white flour. It's basically a drum that turns and the flour drops through a fine screen and the clean bran comes out one end. Almost all our equipment is close to ninety years old. Whether it's new machines or old, there's pretty much only one way to make flour. I maintain the equipment myself and I'm the bookkeeper and the president and the millworker and everything. I started working here for Dad in '76 and I bought the place from him three years ago. Dad used to own the feed mill too and he farmed but we sold the farm in '85. It was about a mile north of town. He was raising spring heifers. We didn't milk cows, which is the big thing around here. The lenders kept saying, "You gotta get bigger," so Dad expanded and the bottom dropped out of the market and he lost his rear end on those damn heifers. Now all we do is what you see right here. Manufacture flour. Which is enough. It's nothing I'm getting rich at, but I'm not complaining. I'm surviving.*

Street rod. PAYNESVILLE

"Are these guys from around here?"

"No, they aren't. Never saw them before. They must have just stopped here on the way to somewhere else."

After the mud rally.
ALBANY

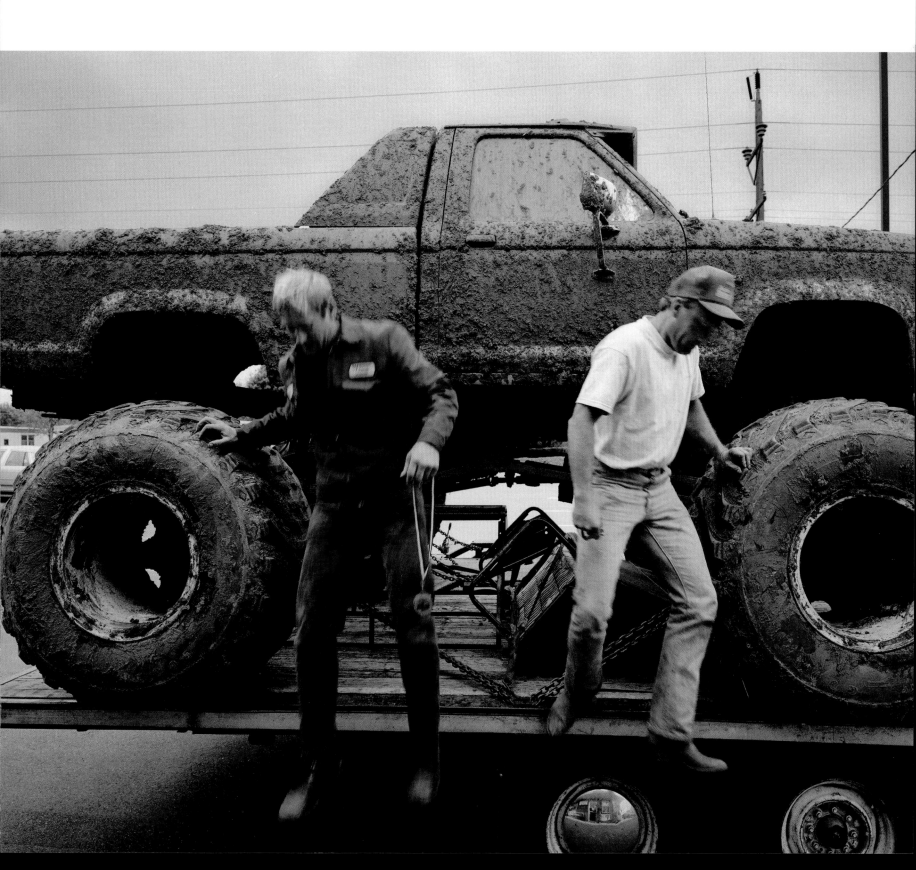

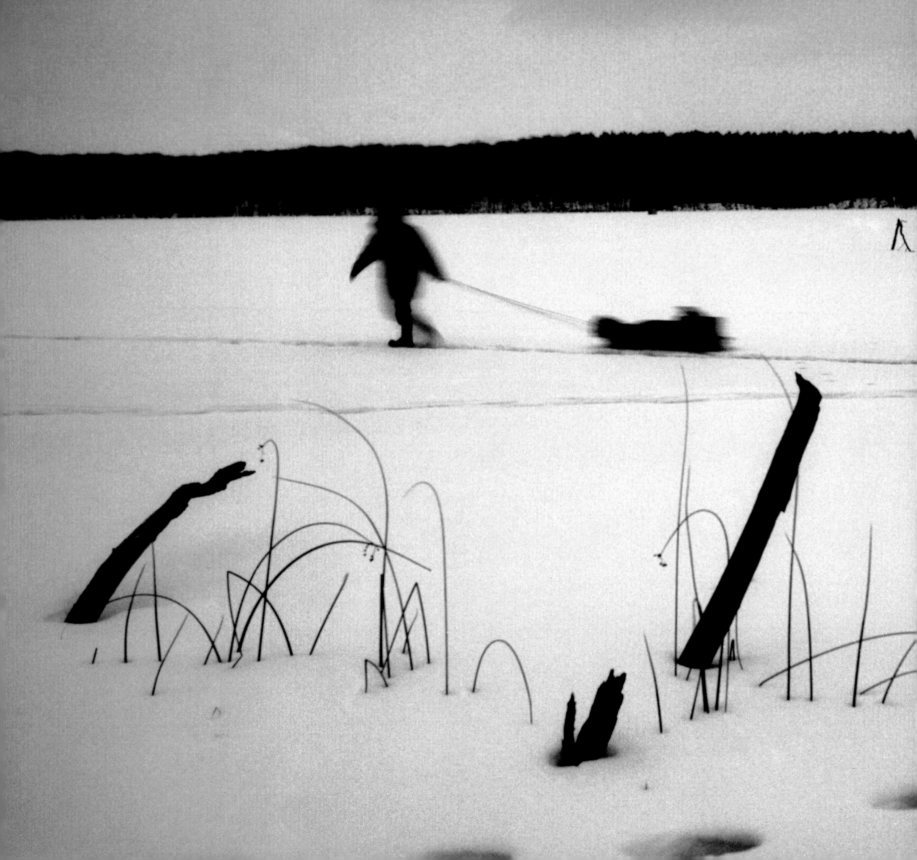

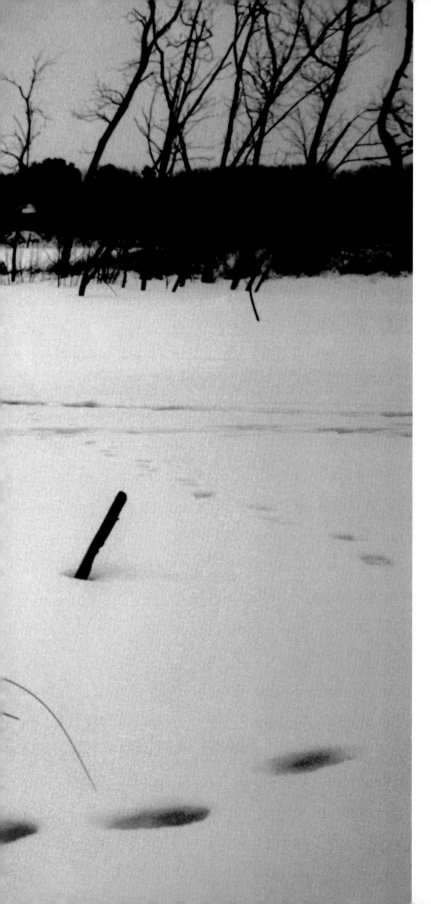

It was the annual January thaw, nature's way of arousing false hopes and tempting the good people of Lake Wobegon to let down their guard and not wear a scarf so that nature can kill them. A form of natural selection to reduce the optimist population and promote the survival of embittered stoics who believe that fate is against them. Which it is.

The thaw means that snow on the roof melts and freezes on the overhang of the eaves, forming a dam to back up the water so it can get under the shingles and freeze and gradually rip our house apart, which is nature's goal, to obliterate us. Nature is not benevolent towards us, it wants us out of here. It's good to know this. In summer, you can almost believe otherwise.

Luckily, summer is soon over. As it turns cold, our mood improves. We're excited. Cold is a stimulant. So is danger. It's good to have nature to deal with. That's why self-pity declines in the fall. People don't sit around and anguish over what to do with their lives. Instinct tells you. You're a mammal. Stay warm. Stay close to the food supply. Shovel the roof. Make babies. Make a few extra in case the wolves get one. And then on a cold night in January, you walk out in the moonlight and against all reason, beyond all expectation, you're utterly happy.

—THE NOTEBOOKS OF CARL KREBSBACH

Lake Sagatagan. COLLEGEVILLE

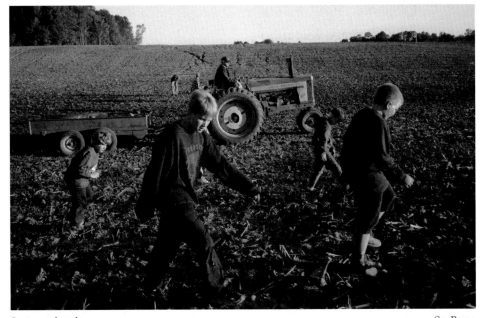

Spring rock picking.

Ervin Kerfeld drives the tractor as his team of rock pickers—sons and grandkids and neighbor boys—clean out his cornfield in the spring, west of St. Rosa. (That was them on pages 10, 11 too.) *Rocks are hard on equipment. They can break the knives on a corn chopper, which cost $80 apiece and there are twelve of those, so that's $960 right there. So we pick about twenty-five or thirty loads every spring and then throw them in a ditch. It's a ritual. We start kids out picking at the age of seven or eight, after school for four hours, so they don't get too tired. They ask me, "Is this rock big enough to pick?" and I say, "No, leave it. It'll be bigger next year."*

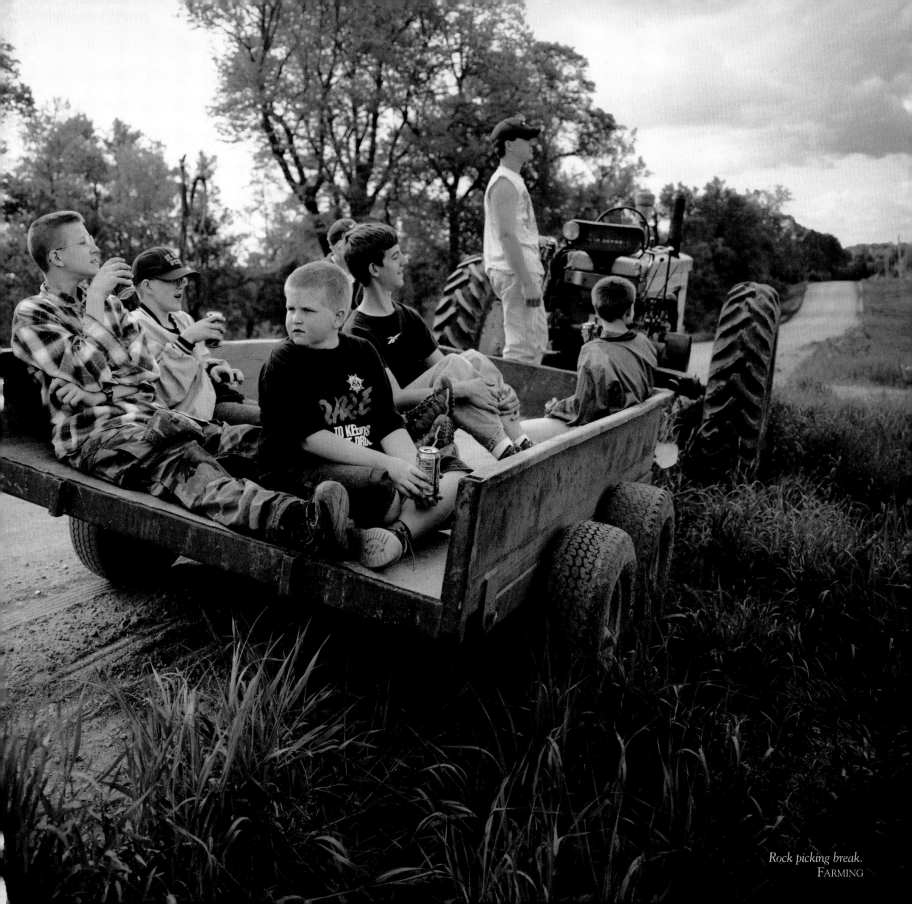

Rock picking break.
FARMING

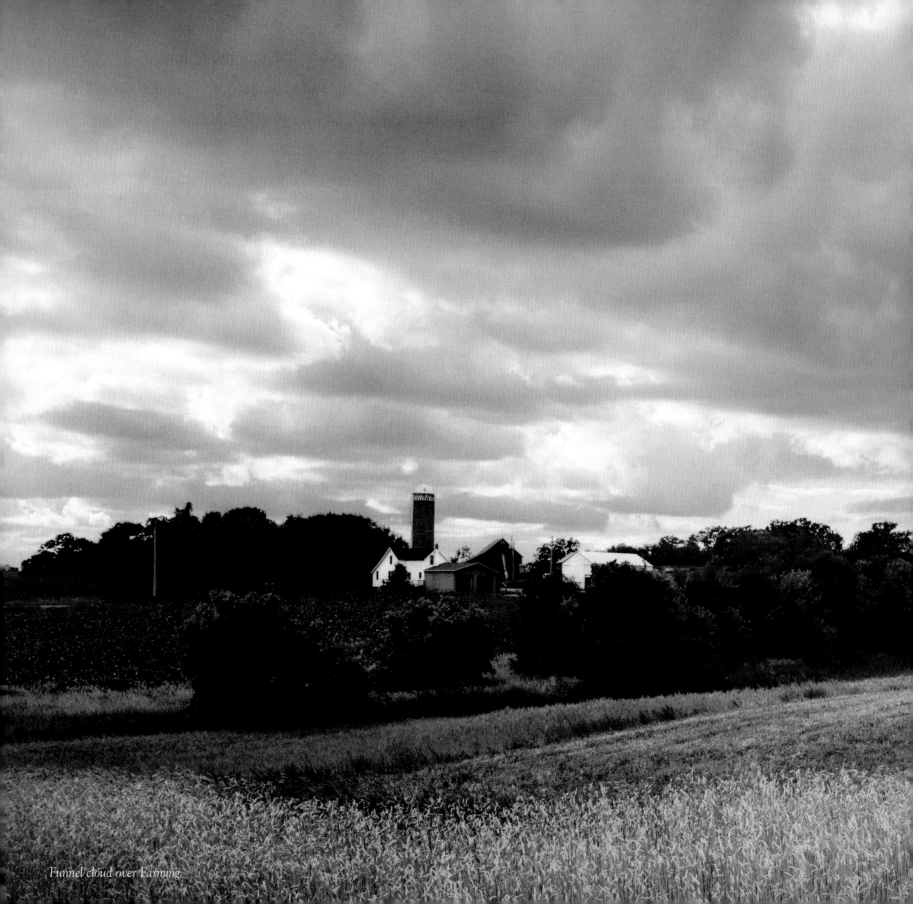

Funnel cloud over Farming.

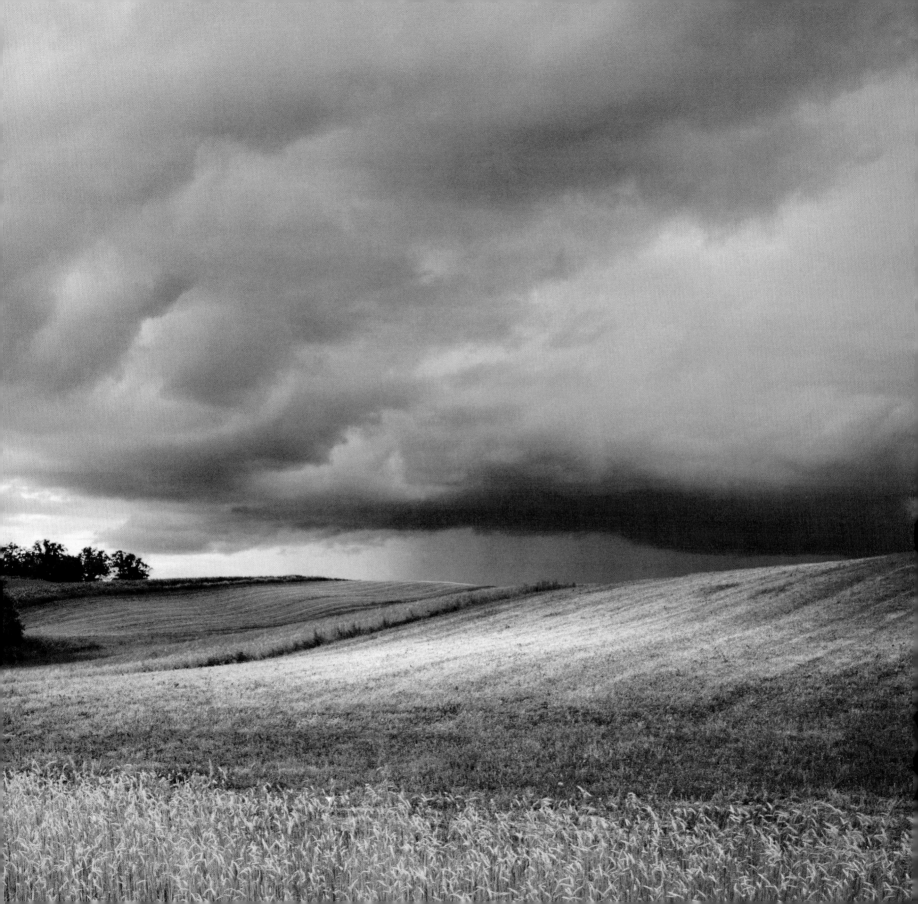

October

LIFE IN MINNESOTA can feel like a bad marriage when winter settles in for six months—somewhere in the dark icy hollow of February you think, *I used to be happy and attractive! I wasn't always this snaggle-toothed crone living in this dank cave of a house! I could be that jubilant young person again!* So you divorce Minnesota and go off and find one who is prettier and wealthier and warmer, such as San Luis Obispo, and next Christmas you write a letter back to Lake Wobegon, all about your new life doing the things you always wanted to do—sailing! riding a horse in the surf! rock climbing! a new religion that isn't based on guilt and ritual! no! it's based on mutual respect and a willingness to explore our spirituality, not just sit in the perpetual twilight and sing gloomy hymns and listen to a man with a voice like a chisel telling you what an abject sinner you are—and you write all about your new friends who are (though you don't say it in so many words) so much friendlier than those dour stoics you grew up with who (you got the impression on your last visit) resent your love of life and your inquiring intellect and your success and devoutly wish a giant earthquake would hurl you and your beautiful home into the Pacific.

But there are no simple changes in this life. You divorce Minnesota for the California coast, a rational move, and all is well for a while, but then October rolls around, and Columbus Day, and you're floating in your pool and suddenly you miss fall. Terribly. You miss the delicious sadness of a fall day, the blazing yellow birches and aspen, the red and orange and yellow maples, the red sumac, the oaks turning orange, the air smelling of old horses and potatoes and wood smoke and rotting logs. The great monuments of trees, the sweet air, the keys to memory, to your story. Having lost October, you have lost your story. You've become an occupant of a house, a credit-card holder, an insuree, a face on a driver's license. October is the connection to when you were eight years old and the splendor in the woods, the pageantry of trees, red and gold and ochre, and the sweetness of the chill air. You long for it. To be restored to your aunts and uncles and the dirty-faced kids you ran around with on the school playground when you fell and scraped your hand on the cinders and went indoors to wash off the wound

and walked down the long dim hallway, the classrooms empty, and you stepped into your classroom with the rows of old desks and the autumn leaves pinned to the bulletin board, and on the blackboard, written in a fine hand, I go you go he goes I went you went he went I have gone you have gone he has gone, and in that moment you first thought, *I will not always live in this town.*

All of the Miesles went through this classroom, your classmates Eunice, Cynthia, Jimmy, Nancy. Two of them stayed in Lake Wobegon and two left. Eunice and Cynthia are still around town, and Jimmy's in New York and Nancy in Minneapolis. They're descended from dirt-poor German farmers who landed here in the 1870s to spare their sons from service in the kaiser's army. Their grandpa Emil raised wheat, their dad Art raised turkeys, and then in 1985, the home place was sold off, and Art and Mary Katherine went to an apartment in Albany.

The four Miesles often go for months without speaking, and then their orbits swing close together again, and if you were to chart these convergences, October would show up again and again.

Father Wilmer knows them—Eunice and Cynthia and their husbands attend Our Lady of Perpetual Responsibility—and today he's wearing the soft brown hat Cynthia gave him for his birthday. She said it makes him look like a poet. That was in June and he hasn't seen her in church since. It's a Saturday, 10 A.M., he rakes leaves in the yard between the rectory and the great brick castle of Our Lady, wearing his old red plaid wool jacket and the brown hat. In this town, a great hat attracts comment, and two parishioners have already stopped to ask, "Where'd you get the cowboy hat?"

"Got it for my birthday."

"Looks good on you. Now all you need is a horse to go with it." And they laughed, as if this were quite humorous, and being the pastor he had to chuckle and grin and shake his head, as if to say, "What a keen wit you

have, my good man!" But it has nothing to do with cowboys. It's a hat like the poet Yeats wore, who wrote:

The trees are in their autumn beauty,
The woodland paths are dry.
Under the October twilight the water
Mirrors a still sky.
Upon the brimming water among the stones
Are nine-and-fifty swans.

Unwearied still, lover by lover,
They paddle in the cold
Companionable streams or climb the air;
Their hearts have not grown old;
Passion or conquest, wander where they will,
Attend upon them still.

HE RAKES THE LEAVES TOWARD THE CURB, as if to burn them in the street, as we used to in Lake Wobegon, instead of forking them into plastic bags, the new edict. After lunch, he will do a baptism as a favor to Eunice, and Cynthia will be there. Their sister Nancy's two boys, eight and ten, from Minneapolis, are the baptizees. Nancy fell away from the faith, apparently—Father didn't delve into this—and is living a (how shall we say?) rather impromptu life at the moment, and Eunice, a good soul, is trying to reach out. Her husband, Jack Schafer, is related to Father on his mother's side.

AT THE MOMENT, CYNTHIA IS IN TOWN killing time, hanging around Bunsen Motors, pretending to look at cars. She had to get out of the house before Daddy drove her nuts. He's staying with her and Richard while Mother goes to New York to visit Jimmy. Daddy is seventy-eight and he's a handful. He doesn't sleep well at night and gets up and roams around and camps in the kitchen and listens to a radio call-in show on which people discuss the conspiracy of the CIA and Air Force

to cover up the existence of alien beings in our midst who are adopting human form and going into the fields of communications and law enforcement. He gets to talking about this and it's hard to shut him up. Eunice thinks he is showing signs of senility. She drove him and Mother to Little Falls to look at Gethsemane Arms, where you can start out in an apartment and get two meals a day in the cafeteria and gradually, as you need more care, progress through various sections of senior living and nursing home all the way to hospice, and Dad wouldn't even get out of the car. "You're trying to get rid of me," he yelled at Eunice, the soul of kindness. "Why don't you just get a gun and look me straight in the eye and shoot me? Instead of stabbing me in the back." Eunice cried about that all the way home. Mother just sat in the backseat and looked at scenery.

Cynthia is slight and small, with the Miesle beak and brunette hair and flat nose. She is standing in the back of Bunsen Motors, in a doorway so nobody can see her from the street. In Lake Wobegon Catholics don't drive Fords because the Bunsens are Lutherans and some of what you pay for your car will wind up going toward teaching heresy to small children, whereas if you buy from Krebsbach Chev some of that money will go to the holy Catholic Church and the African missions.

A Catholic driving a Ford would be a hot topic around town, that's for sure. People would be polite, they'd say, "She has a right to drive anything she wants," even Donnie Krebsbach would say, "I've got nothing against Ford, they make a good car, if that's what you want." But people would be thinking, I always knew there was something not right about her. She never really fit in here. Poor thing. I wonder if she and Richard are having marital problems. I wouldn't be surprised. She hasn't been to Mass since June. Interesting. And then she agreed to be godmother to her nephews. Nancy's boys. How can you be entrusted with the spiritual upbringing of two lit-

tle boys if you can't even get your own butt to church on Sunday? Oh, well.

"You want to drive it?" Clarence Bunsen.

"I don't know."

A red Explorer. A big tank of a car. She likes the name, Explorer. Get off the road and drive cross-country and spend twenty-five grand for a car not of your faith. A car that is known to tip over. A car that gets about eight miles to the gallon. Impractical. She likes that. Why not go for impulse for a change?

"It's a good runner, good starter in the winter," he says. "And that price—we've got some slack there, we could come down on that a little."

"I shouldn't even be here thinking about this, you know."

"Well, I know, but times change. A person has to please himself. I mean, Chevy makes a good car, it's not that, but a lot of people think they don't handle all that well." He jingles the keys. "You want to get in?"

This must be how adultery feels. You stand next to a strange man with keys in his hand and you think, *How did I get to this point? And what do I do now?*

"Let me think about it." And she ducks out the back door and heads for the Chatterbox Cafe, taking a long route past the tavern and across Main Street and through Ralph's Pretty Good Grocery parking lot to the shore of the lake. The trees on the north shore include a long string of bright red maples. She's meeting Eunice in the cafe in an hour or so. Eunice took Mother to the airport this morning and she's bringing the boys up from Minneapolis. Nancy can't come to her sons' baptism, she has to see her therapist.

SUCH A BEAUTIFUL FALL DAY, Cynthia thinks. *Mother would love this.* Mother is the easygoing one who believes in people enjoying today and being helpful and kind and working together to make a better world. Dad's philosophy is:

Whatever you want you're not going to get, so don't even think about it. He was a turkey farmer. The smell was on her clothes and her hair all through high school. She still has nightmares about finding turkey droppings on her best black shoes. Cynthia wanted to move to California and go to school but she was dating Richard Krienke and he wouldn't go and they were such a nice couple, everyone said so, and she wanted to be happy and make him happy, so off she went and married him, and you know something? It could have been worse. Thirty-two years. He's a little quiet for her taste, a little too close to the middle, but he has his moments too. Like last July on their anniversary, he made love with her in the cemetery. How did he know she'd always wanted to do that? They went at 11 P.M. and spread a blanket over the graves of her grandparents, Karl and Tillie, and stripped naked and did it right there under the stars, over the moldering dead. Knocked themselves out.

EUNICE IS AT THE AIRPORT WITH MOTHER, pointing her toward the red concourse, Gate 27, the flight to La Guardia. She woke up at 5 this morning because she was roasting. Eunice is a low-thermostat person and always has been. Sixty-six or less is conducive to clear thinking. She is always fighting Jack over thermostat control. He gets up in the night to turn it up, she goes downstairs to turn it back down. This morning it was 71. She turned it down to 60. Then she had a panic: she'd forgotten to arrange for a baptismal lunch for Joaquín and Oscar— you can't receive God's blessing and be marked as one of His own and committed to His love and mercy and then go home and watch cartoons on television, can you? No, you must sit down to a festive lunch with your aunt Cynthia and uncle Richard and aunt Eunice and uncle Jack and your grandpa—so she called Dorothy at the Chatterbox at 6 A.M. Eunice is the oldest of the Miesles, she's used to arranging things.

"We'd like chicken noodle soup and tunafish sandwiches and a nice coleslaw," she said. "And could we decorate that back booth with a little crepe paper and whatnot? And we'll need a cake. A white cake with their names on it."

And then Mother came down for breakfast in her blue traveling suit, her little black grip packed, her hat and coat ready, the plane ticket.

"Are you excited?" Yes, Mother said, she was. She sat at Eunice's kitchen table, with her orange juice and toast and bowl of Wheat Chex, and said, "Do you think this trip is a big mistake? I could call up Jimmy and tell him, he'd understand."

"No, you go, Mother. We'll take care of things."

"It doesn't seem right to go gallivanting to New York when my grandsons are getting baptized."

"You've had this trip planned for two months. We didn't know for sure about the baptism until last Wednesday."

EVERY WEDNESDAY NIGHT Eunice goes to Minneapolis to fix the boys' supper while Nancy goes to her A.A. group. Nancy is the youngest, forty-three. She goes to a church in Minneapolis, the sort where there is no baptism and you don't necessarily have to believe in God and they don't call it a church, they call it a community. Nancy's latest boyfriend is the church janitor, fifty-six, twice divorced. Eunice met him once and underneath the ponytail and the Grateful Dead T-shirt, he seemed okay, a little slow on the uptake, but maybe that comes from heavy drug usage The temperature in that church was up around 78, like a greenhouse. Nancy's boys went through some sort of Ceremony of Affirmation where everyone stood in a circle and held hands and there were bells dinged and the minister in her white caftan held a candle and read from Whitman's "Song of Myself" and there you are, affirmed in your personhood, goody-goody for you,

welcome to the human race. Somewhat thin compared to the glorious resurrection of Our Lord and Savior Jesus Christ, but whatever floats your boat, Eunice thought. Still, it'd be nice to put the mark of the Roman Catholic Church on these boys. They might grow up to be heathens but God could look down and see that mark and say, "Well, we'll see what can be done."

She talked Nancy into it on the grounds that it would mean a lot to Mother and Dad, who were not getting any younger, after all. She used the word "reconciliation," a good Nancy word. She said the baptism of Joaquín and Oscar would "complete the circle." Nancy dithered over it for three months, meanwhile Jimmy asked Mother to come to New York to see him dance. He's forty-five, his dancing career is ending, and Mother hasn't seen him perform since *West Side Story* in high school. A real shame. He and Mother always were so close. Eunice guesses that he is going to take the occasion to tell her that he's gay. Not that it matters. Mother probably guessed this long ago, just as Eunice did. Unless maybe Jimmy isn't. Maybe he just doesn't like women. Like other men in this family.

"Is Jimmy putting you up in a hotel?"

"He said it's a B and B run by a friend of his."

"I worry about Jimmy sometimes. We're so out of touch with him."

"He seems fine."

"What is he going to do when he quits dancing?"

"He's doing something with computers, I don't know what."

"But he's all alone out there."

EUNICE AND MOTHER LEFT THE HOUSE at 8:30. The plane was scheduled to depart at 11:15, Eunice would pick up the boys at Nancy's at 11:30, the baptism is back in Lake Wobegon at 1:30, and lunch will be at 3. She leaves the airport at 11 and goes to her car on the fifth level of the parking ramp. She is wearing an elegant white pants suit for the occasion. In the olden days, you'd dress up for a baptism, the women would wear white gloves, the men would shine their shoes and have a white flower in their lapels, but those days are gone. Back in the days of Vatican II, the Church decided that since God is no respecter of class or position, anybody should feel free to come in any old thing they want to wear, and a few years later nobody but old people got dressed up, everybody else looked like they just came in from mowing the grass. A real shame, if you ask me.

She heads for Nancy's dingy little apartment in south Minneapolis near Lake Hiawatha. A stucco duplex and Nancy lives upstairs. Joaquín and Oscar are watching television. Two men are battling on the edge of a high cliff, swinging chains, doing kung-fu, kicking, slashing, both of them bruised and bleeding. "We're going to church today, remember?" They look blankly at her. Nancy is on the phone in her bedroom.

Old posters on the walls from San Francisco. The Mime Theater, Bread & Roses, the Grateful Dead, Golden Gate Bridge. Nancy followed Jimmy there when she was eighteen and she burned a lot of candles in a few years. He was studying dance and bartending in a Mexican restaurant and he got her a job waitressing and one thing led to another and one night she hooked up with Ramón, a real shyster, but Nancy was deeply into Hispanic culture and felt it was warmer and more genuine than Anglo—Eunice had never heard the word "Anglo" referred to herself, she always considered herself German—and Ramón and Nancy lived together for three years and Nancy learned Spanish and involved herself with the Latino community and had the two babies and when Oscar was two months old, Ramón decided to move on, and Nancy came back to Minnesota to try to get her life back together. An ongoing process.

Eunice asks the boys to put on clean shirts and wash their faces, please. "It's your baptismal day, we want you to look nice," she says. Joaquín tells her to go fuck herself. She smiles down at him and says, "I love you, Joaquín, and it hurts me to hear you say that." So he says it again.

Part of the problem is that Nancy keeps the thermostat set to 72. Much too high. You get overheated and it's no wonder your children talk like gangsters. It's just like Jack. He can't bear anything under 70. No wonder his metabolism is screwed up.

FORTY YEARS OF MARRIAGE as of May fifteenth. She wanted to have a party, Jack didn't. She wanted to go to Chicago for a romantic weekend for two at a nice hotel. He groaned at the thought. He hates to travel. She can't get enough of it. He can't watch enough football and golf. She loathes every sports announcer on TV, that bad combination of Baptist preacher and aluminum-siding salesman. Jack is an insurance salesman who eats like a farmhand, so he weighs 280 pounds and has high blood pressure and wheezes on the stairs and is content to play hanky-panky with her once or twice a year, and she is a size four and a vegetarian and puts in five miles a day on the stationary bike. People keep telling her what a wonderful and generous and funny man Jack is. How do they know this? Why doesn't he bring himself home?

At their wedding, the priest read the passage about the wedding feast at Cana where Jesus turned the water into wine. When the ruler of the feast tasted it, he said, "Most people serve the good wine first and then the worse wine, but you've saved the best for last." And Eunice looked sidelong at her stocky husband and thought, *Life is good when you're young and then gradually it gets worse. There is no best later on. This is it.* They went to a motel and fumbled around in bed and then he got really excited and then it was all over. So much for good wine. Bring on the coffee.

Sometimes she thinks of Paul Werner, her boyfriend in high school, and how her skin felt when she walked next to him, his arm hooked around her waist. Paul lives in Santa Monica, he's an architect. Sometimes when she isn't getting along with Jack, she imagines running into Paul and him inviting her out for a drink. When she really isn't getting along with Jack, she imagines she's a widow and Paul comes from California for a weekend and winds up staying for a month and after that she puts the house up for sale. She isn't about to go looking for Paul, though. That's 75-degree thinking. A low-thermostat person knows better.

NANCY GETS OFF THE PHONE AND HUGS EUNICE. She's crying. She was talking to a friend in California who has been diagnosed with breast cancer. Maybe she should fly out there and comfort her. Sometimes you can get really cheap fares at the last minute. "Your place is here with your children," says Eunice.

"Don't tell me where my place is," says Nancy. "It's my life, not yours."

Eunice is sorry. She didn't mean to interfere. But Nancy needs to sit down and discuss what's going on between them. "I need to get the boys to the baptism," says Eunice. "I need to talk," says Nancy. Issues need to be faced. Eunice is a controlling person and Nancy has an issue with this. She feels that Eunice doesn't respect the changes she's made in her life. So Eunice is late when she and Oscar get in the car. Joaquín isn't going, he'd rather watch TV. Eunice heads north. She tells herself to calm down, don't speed, it doesn't matter if you're late. But she is pushing 80 when she hits St. Joseph and gets off the Interstate.

MOTHER IS GOING TO SEE JIMMY DANCE at the Brooklyn Academy of Music with the Lindsay Longet Dance Experience. Eunice saw them a few years ago in Minneapolis.

Something called "Cannabis Cycle" in which the dancers dashed toward the audience with fists upraised and stopped at the footlights and yelled "Yes!" and one called "Hommage/Adiós Jerry Garcia," which had a lot of strobe lights and a long electric guitar solo and orange Spandex. Jimmy was in the first half of the show. He took Eunice backstage during intermission. Dancers wandered half-naked in and out of dressing rooms, smoking, the place reeked of sweat and vomit—Eunice noticed the pails in the wings. Men and women sat on the floor stretching and warming up. It was Jimmy's world, everybody knew him, he walked around drinking a Heineken and eating chunks of cheese and fruit off a buffet. He was slim, blond, good-looking, her brother, in a pale sort of way. She wanted to be proud of him. He always was such a quiet kid. Afraid of Dad.

It was lucky for him that Dad hated to travel. So Mother went to New York. It might be his last appearance with Lindsay Longet. She was starting a new company and hadn't asked him to join. Too old and both his knees are shot. So he has a nice little part as a flower in a new work, "Symbiosis."

"Your uncle Jimmy is going to be a flower and Grandma is going to New York to see him," she says to Oscar.

AT THE CHURCH, CYNTHIA AND RICHARD and Jack and Grandpa are waiting, drinking coffee in the pastor's office. It's quarter to two. Jack and Richard are discussing the new governor, Ventura, the skinhead wrestler. They both voted for him. The guy makes a lot of sense, says Jack. So he's different. Maybe it's time for something different. Father Wilmer asks Cynthia for the second time what she's been up to lately. "Same old same thing."

Actually, she's been slipping around to other churches, shopping. In Minneapolis she attended a very high Episcopalian church with a rector who spoke through his nose and a boy choir and men wearing dresses swinging smoke pots. She had a look at the Unitarians one Sunday when they were talking about poverty in Guatemala. Then she attended a charismatic Catholic church for a couple of Sundays. She snuck off, telling Richard she didn't feel like going to church, and took the back roads over toward Holdingford to an old schoolhouse out in the country. No sign out front—it's an underground congregation led by a renegade nun named Sister Aurelia—and about thirty cars parked along the road. She walked in and people were standing and weeping and hugging each other. A young woman in a faded cotton shift stood in front holding a baby. She was crying and talking about how life had never been so hard for her and she had never felt so lonely and depressed and yet how good Jesus was and how He showed His kindness and how whenever she drew near to Him He told her of His love for her—and everyone shouted, "Yes! Thank You, Jesus!" and Sister Aurelia threw her arms around Cynthia and said, "The love of our Precious Savior for you"—and yet, they were still regular Minnesota people, and when the service was over, they dried their tears and sat down to a hefty lunch of ham and scalloped potatoes and a tuna noodle hot dish and a big orange Jell-O ring.

AND THEN THE PHONE RANG in the church office. It was Jimmy in New York, distraught, wanting to talk to Eunice.

"She's not here yet," said Cynthia.

"Has Mother left for New York?"

"I think so. Eunice drove her down to the Cities this morning." He groaned. "Why?"

"I can't have her come see this dance," he moaned. "I just learned this morning that I'm going to be dancing naked."

"So? Mother's eyesight isn't that good."

"I got her a seat right down front."

"So put a condom over it."

"Very funny. Have Eunice call me."

"There's nothing Eunice can do. Mother's on her way."

He groaned another low aching groan.

She was looking at Dad, who was half asleep in the corner. *Your son is going to be prancing around in his birthday suit in New York City in front of thousands of people including his own mother. Did you ever consider this possibility when you got married?*

EUNICE AND OSCAR ARRIVE AT TWO, Eunice a little out of sorts, Cynthia thinks. *Good. Nice to see the Executive Sister get her undies in a bunch.* Father Wilmer says hello to Oscar and asks him about school and Minneapolis and the Twins, but Oscar isn't feeling sociable, so Father leads them up to the sanctuary, to the baptismal font in the back and passes copies of the Ritual of Baptism around and right then Dad decides he needs to use the toilet. The march upstairs has awakened his bladder. "Could it wait fifteen minutes?" snaps Eunice. No, it can't.

Dad trudges back downstairs.

"Are there any questions about what we're doing?" asks Father helpfully.

Jack clears his throat. "Aren't you supposed to examine the candidate for baptism? Ask him questions?"

"No. That's catechism. Baptism is the Church gathering around a child and pledging our love and care in bringing him up in the gospel of Jesus Christ. No questions necessary."

"What if he doesn't believe in God?"

"That's our job, to teach him."

"What about his mother?"

Father Wilmer looks down at the font. A small green leaf is floating in it. "We'll simply have to carry on in her absence," he says.

Cynthia wishes Jack would push the priest a little harder. It's Nancy's decision how to bring up her kids, it isn't Eunice's. Eunice in her smart white suit like some super nurse, always bustling around, butting in where she isn't invited.

A small hard silence. "How many of these do you do in a year?" says Richard. Cynthia closes her eyes. *Men and their small talk. How much does a baptismal font like this cost? How much water do you use?*

"It varies."

Finally Dad returns. His fly is open, Cynthia notices. The men of this family are suddenly into self-exposure.

The baptism takes about eight minutes. The four sponsors affirm their faith in the gospel of Jesus Christ and renounce the devil and all his pomps and the child is anointed and tipped forward and the water applied in the name of the Father and the Son and the Holy Ghost and then Father Wilmer says, "Today we welcome Oscar into the family of God, as Jesus welcomed the little children to come unto Him. And we also affirm that we are the children of God and that if we're to teach Oscar about God's love, we must show it in our own lives, with a whole heart. A whole heart, not one divided against itself, not one tormented by questions and doubts and fear but one that is of one mind. A cheerful heart. Taking one thing at a time. One day at a time. Whatsoever ye do, do it heartily, as unto the Lord, and not unto men. Consider not what ye shall eat nor what ye shall wear—consider the lilies of the field, they toil not and neither do they spin, and yet I say unto you that Solomon in all his glory was not arrayed like one of these. So too, ye of little faith." And he prays for Oscar, his hand on the boy's dark hair.

AT THE CHATTERBOX CAFE they file into the booth which Dorothy has gussied up with white and blue

streamers. Cynthia gets trapped into sitting next to Eunice. Jack waves her in to the bench next to Eunice—"Blood is thicker than water"—and she and Eunice and Dad sit on one side and Richard and Jack and Oscar on the other. Oscar has not said boo all afternoon. "How's school, Oscar?" *It sucks.* Then she remembers to tell Eunice that Jimmy called.

"He's going to pick up Mother at La Guardia, isn't he?"

"Yes, but he was hoping she wouldn't come. Turns out he's going to be doing his dance in the nude. Mother is going to see more of her boy than she bargained for."

Eunice doesn't think this is funny.

"He has to tell that dance company to let him wear clothing. He has to. He can't do this to her."

"Do what?"

"Embarrass her in public."

"Nobody there knows her. What's the embarrassment? That his wiener isn't bigger?"

Eunice turns away from her and talks with Dad. That's her way. Cross her and she shuts you out.

EUNICE DRIVES TO HER HOUSE WITH OSCAR, who makes a beeline for the television and then is astonished that she doesn't have cable. Eunice will take him home tonight after supper. Jack is fixing supper. He waltzes in a few minutes later with a bag full of groceries. Eunice can smell the steaks. Disgusting. She gives him a peck on the cheek. "Thanks for coming."

"No problem."

She calls Jimmy's apartment in New York. No answer. He lives in a one-bedroom walk-up in the West Seventies. Cynthia saw it once. Drug addicts asleep in the vestibule, you have to step over them. The bedroom he sublets to an actress named Cheryl who is usually in California. Jimmy wrote to Eunice two years ago, *I read an anguished memoir about dancing in New York by a woman whose early years here weren't so different from mine, except she found success and I didn't. Funny, I don't feel anguished at all. Sometimes I've thought life would be easier if I were a lawyer, but I'm a dancer. So what are you going to do?*

Eunice opens a bottle of wine. An unusual step for her. She pours a glass for herself and one for Jack, who is rubbing some powder on the meat. MSG, probably. Oscar has inexplicably fallen asleep with the TV blaring. She eases down the volume. And she checks the thermostat, which has, inexplicably, been set at 70. She turns it down.

"What's going on with Cyn?" Jack says. For a split moment she thinks he's asking about sin. "Someone said she was in Bunsen Motors looking at an S.U.V. Her and Richard doing okay?"

"I don't know. Nobody tells me anything."

"It's her business what she does, but I'd have a hard time facing Donnie Krebsbach if I were her. Nothing wrong with a Chev that I can see."

The phone rings. It's Jimmy. He's at La Guardia. Mother's plane is late. He sounds like he's at the end of his rope. He has a rehearsal in one hour. It's rush hour. The airport's jammed. It's going to take him forty-five minutes to get home. Could he have a limo driver wait for Mother holding up her name on a card? Would that be okay? Would she know what to do?

"She's expecting you."

"I *know* that. But I have rehearsal. You don't just stroll in late for these things."

"You don't just leave your mother stranded at La Guardia, either."

He heaves a sigh.

"And one more thing: tell that choreographer Louise Whoever that you're not dancing naked in front of your own mother. Tell her that. Have some decency." And she hangs up. A bad thing to do but she's about to burst

into tears. Jack asks her what's wrong. Nothing. Nothing new. The same old things that always were wrong.

CYNTHIA AND RICHARD DRIVE HOME from the Chatterbox with Dad and get him settled in a lounger chair with the newspaper, and Richard says to her, "What are you up to?" Their long-standing code for wanting to make love. "Nothing," she says.

"I was thinking of lying down for a while."

"I'll come and lie down with you."

A MONTH AGO SHE WAS ONLINE and searched for her first love from high school and found him in a small town in Nebraska. A Lutheran minister and deeply unhappy. Wrong job, wrong wife, wrong place, his kids are strangers, and when you're a minister in a small town, there is nobody to tell your troubles to, except your wife, and she's high on the list.

They talked. It was exciting. He said he'd been thinking of her for years, he said, "It'd be nice to see you. How about we meet in Minneapolis? We could have dinner and talk and dance. Do you still like jazz?" he said.

"I do," she said.

"I always thought of you as a kindred spirit," he said. "I think maybe a person only gets one of those in his lifetime and you're mine."

They talked for hours and she thought, *I'm falling in love with this man.* And then suddenly he had to leave. His wife came in the room. "Bye," he said. And was gone. And she hasn't looked for him since.

Her marriage is okay. All these years it's mostly been nice. It got a little better and then it stayed pretty good. Maybe he read a book about sex and something clicked. The tall naked man lies next to naked her in the dim room on an October afternoon, on his left side, his left arm under her neck, his right hand lies flat on her pubic bush.

"How many times have we made love now?" He doesn't answer. Maybe he's trying to compute an answer. Then she hears Dad yell something downstairs. Maybe he is having a heart attack and calling for help, and then she thinks, *Let him die,* and then she feels bad about that, but she thinks, *If he yells again, I'll go downstairs.*

"LET'S GO TO MEXICO FOR CHRISTMAS," she says. "I don't want to spend Christmas here."

"What about the kids?"

"They can have their own Christmas."

And right then came the unmistakable crack of the gun from downstairs. Richard leaped up, pulled a blanket around him, ran out, and she threw on a bathrobe and followed. He took the stairs three at a time and when she got to the kitchen, he had the rifle in his hands and was holding on to Dad, who sat perfectly still on a stool, leaning over the kitchen sink.

She screamed, "Oh my God! What are you doing?" She took a deep breath.

"I shot at a squirrel."

She took a step toward him. "Why do you do these things? You scared us." And then she put her arms around him. She hadn't done that for years. She hugged him until he put his arms around her. She said, "The love of our Precious Savior for you, Daddy."

Coffee was burning on the stove. Dad said he was trying to kill the squirrel that was feasting off the bird feeder, the big fat one. "Tired of looking at him." He had raised the screen in the window over the sink and set the barrel on the windowsill, between a porcelain swan and a bear with a planter attached and a cactus in it and two little pictures of his granddaughters, and he took his shot and missed. The squirrel was back in the feeder. The kitchen smelled of gunsmoke. A very quiet voice on the radio said we are expecting a low tonight around 45. ☐

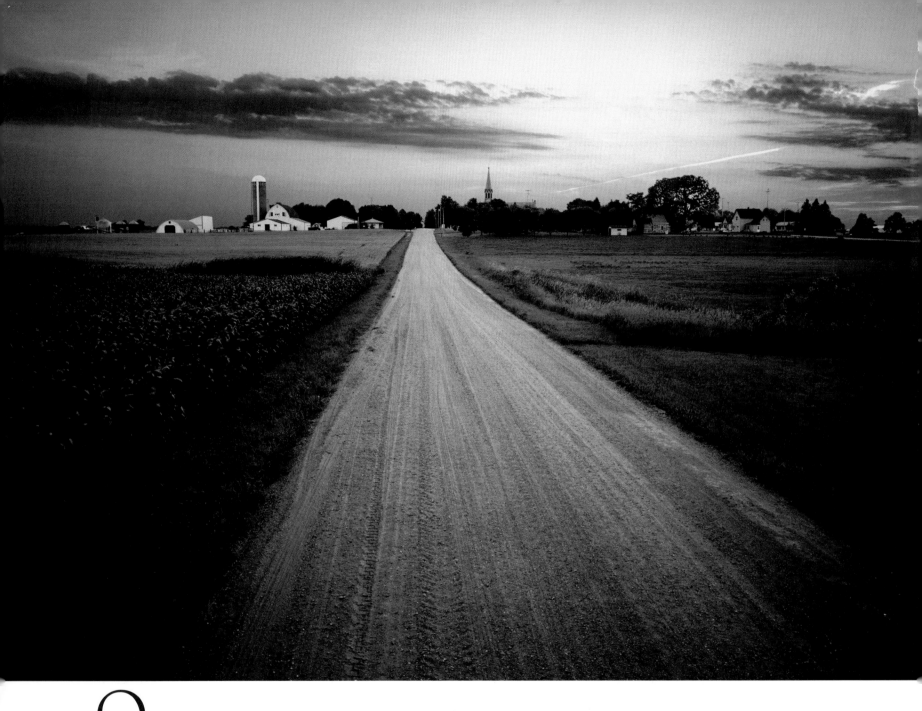

On the cover: St. Anthony, a village northeast of Freeport. Shirley Schiffler, a member of the town council: *We put up a sign saying population eighty but we counted sixty-eight not long ago. Though the last three or four houses sold in St. Anthony have been sold by seniors to families with kids, so maybe the population is up. The lots are big and half the people have vegetable gardens, at least a couple rows of peas and corn and some onions and tomatoes. It's nice black dirt. The tavern is the only business, Schiffler's, run by my brother Ervin. We used to have a grocery but it closed. The council tries to meet three to four times a year. We meet every May to approve the liquor license. And in September we get together to see if there are any problems. And we meet in December to close the books. We deal with things like people not cutting their grass or weeds. No complaints about taxes. No problem with the bar.*

A Note from the Photographer

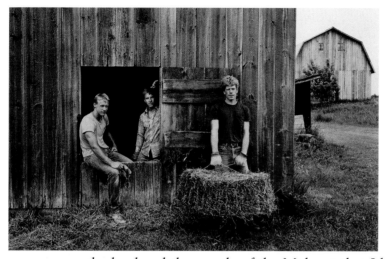

I T STARTED MANY YEARS AGO, this feeling I get when I'm out on the farms and prairies of the Midwest. I remember when I started working on the *Minneapolis Tribune* as a photographer back in the seventies. My boss, Earl Seubert, would say, "It's a slow news day, so why don't you go out and find us a picture." So for more than a decade I had this job where many days I'd drive beyond the Twin Cities in search of whatever caught my eye. As long as I showed up and had a print for the early evening state deadline, I was on my own. I'm still amazed they paid me for this.

So this was the beginning of a relationship between the land and the people of the Midwest that I have carried inside me for the last thirty years. I'm not sure I can actually explain why this relationship connected so deeply. But what attracts me is the land west of the upper Mississippi cleared by immigrant farmers in the 1850s, sectioned off into farms, and sprinkled with small towns with neat, spare main streets. So it is here where the sky reached out to the prairies, I chased the weather and light with my cameras, and the bond began to form.

These feelings became strong enough that I eventually left newspapering and began a journey on my own with my newfound love, a 4 x 5 field camera. For a year I traveled and made images of Midwest people and landscapes. Occasionally I'd journey to where farm caps gave way to cowboy hats. The high plains intrigued me, but I always pulled back east of the Missouri River.

I sent my prints to *National Geographic* magazine with the encouragement of Kent Kobersteen, a *Minneapolis Tribune* colleague who had moved on to *Geographic* as an editor. Ironically, it was my black-and-white, 4 x 5 Midwest work that caught the *Geographic*'s attention and pulled me from my long drives in the country. Now there were longer trips to the Arctic's Northwest Passage, Great Lakes, Alaska highway, Wyoming, Puget Sound, and Labrador to name a few. Eventually, I took a position at *National Geographic* magazine (Washington, D.C.) as an illustrations editor. But after four years of watching the weather from behind sealed glass windows and editing other people's photography, the desire to be back on the road became too strong. I resigned.

Kobersteen, who is now director of photography at *National Geographic,* and Bill Allen, the editor, were looking for a photographer to join Garrison Keillor's search for the real Lake Wobegon. I was their choice. So there I was after a fifteen-year pause, driving out from Minneapolis in a rental car, my tripod and 4 x 5 camera in the backseat, in search of the mythical Lake Wobegon. After full days of photography, I'd spend an hour each night in the bathroom of the small motel in Albany, Minnesota, where in total darkness I'd load sheet film for the next day. It was during this time my mind traced back across all the forgotten moments and all the pictures I'd proudly submitted to the newspaper as a younger man. It all came back to me like discovering an old family album, proving once again that some of the best moments in life revolve around what we call home.

—RICHARD OLSENIUS

Fireworks.
BOWLUS